NEW IMAGES FROM SPAIN

New Images from Spain

BY MARGIT ROWELL

This project is supported by the
Comité Conjunto Hispano Norteamericano
para Asuntos Educativos y Culturales, the
Instituto de Cooperación Iberoamericana
and The Merrill G. and Emita E. Hastings
Foundation

THE SOLOMON R. GUGGENHEIM MUSEUM, NEW YORK

Published by

The Solomon R. Guggenheim Foundation, New York, 1980

ISBN: 0-89207-023-4

Library of Congress Card Catalogue Number: 79-92992

ARTISTS IN THE EXHIBITION

SERGI AGUILAR

CARMEN CALVO

TERESA GANCEDO

MUNTADAS/SERRÁN PAGÁN

MIQUEL NAVARRO

GUILLERMO PÉREZ VILLALTA

JORGE TEIXIDOR

DARÍO VILLALBA

ZUSH

LENDERS TO THE EXHIBITION

Sergi Aguilar

Carmen Calvo

J. Carrillo de Albornoz, Granada

Font Diaz, Barcelona

Teresa Gancedo

Gloria Kirby, Madrid

Collection Lambert, Brussels

Muntadas/Serrán Pagán

Miquel Navarro

Guillermo Pérez Villalta

Enrique del Pozo Parrado, Madrid

J. Suñol, Barcelona

Jorge Teixidor

Darío Villalba

Zush

Museo de Arte Abstracto, Cuenca, Spain

Galería Vandrés, Madrid

PREFACE AND ACKNOWLEDGEMENTS

New Images from Spain is meant to fulfill two of the Guggenheim Museum's longstanding commitments: the first to younger artists whose work has not reached a wide audience; the second to artists from abroad and thus to internationalism. Analogous aims were pursued very recently through the presentation of *British Art Now: An American Perspective* and in years past in selections such as *Amsterdam-Paris-Dusseldorf* (1972) and *Younger European Painters* (1953). The specific rationale for *New Images from Spain* is established by Margit Rowell, the exhibition's curator, in the subsequent pages of this catalogue.

The present exhibition, like all group shows of artists from abroad, incurred considerable costs: extensive travel by the curator was necessary and complex logistics were involved in the documentation of material and its eventual presentation at the initiating museum and subsequently at other institutions in the United States. *New Images from Spain* could therefore be brought to this country only with the generous support of Spanish cultural agencies and through the initiatives of their presiding officers. Among these, specific thanks are herewith offered to H. E. Manuel Prado Colón de Carvajal, Ambassador President of the Instituto de Cooperación Iberoamericana; H. E. Amaro González de Mesa, Director General of Cultural Relations, Ministry of Foreign Affairs, Madrid, Joint Chairman of the Spain-U.S. Joint Committee for Educational and Cultural Affairs; and Hon. Serban Vallimarescu, Counselor for Cultural and Information Affairs, Embassy of the United States to Spain. That such help became available is due in large measure to the interest and commitment of the Spanish authorities — a commitment, it should be stressed, that did not in any way inhibit the Guggenheim's free and wholly independent assertion of its qualitative judgements. The following representatives and officials of the Kingdom of Spain have for this reason earned our special gratitude: H. E. José Lladó Ambassador of Spain to the United States; H. E. Javier Tusell, Director General Patrimonio Artístico y Cultural of the Ministry of Culture; H. E. Rafael de los Casares, Consul General of Spain; Hon. Pablo Barrios Almazor, Secretary of the Spain-U.S. Joint Committee for Educational and Cultural Affairs; Hon. José Luis Roselló, Cultural Counselor, Mr. Ramón Bela, Executive Secretary of the Spain-U.S. Joint Committee for Educational and Cultural Affairs.

Exhibitions of contemporary art, in addition to providing information, are also potential sources for museum acquisitions: here again the Guggenheim depends upon outside help to achieve its aims. In the current instance, our goal was to purchase one work by each of the nine artists represented in the exhibition: assistance was provided by Mrs. Gloria Kirby and by The Merrill G. and Emita E. Hastings Foundation and its Trustee, Mrs. Elizabeth Hastings Peterfreund, whose generosity assured the funds necessary for the purchase of several works. In addition, we were fortunate to receive gifts from anonymous donors. The opportunity to enrich our collection with works

by younger artists and thereby keep pace with the developing art scene may well be the most important aspect of the Guggenheim's international exhibition program.

Our thanks must also be expressed to the lenders whose willingness to part with their possessions is greatly appreciated. Except for those who wish to remain anonymous, lenders are separately listed in this catalogue.

Finally much credit is due to Margit Rowell, the Guggenheim's Curator, who undertook the difficult task of selection of *New Images from Spain* and staged the exhibition in this Museum. The bases for Margit Rowell's selective judgements are articulated in her own preface and therefore need not be stated here. In view of the often strenuous differences of opinion that pertain to the evaluation of current art (a notoriously hotly debated subject), it is appropriate to affirm our unqualified confidence in Miss Rowell's professional capabilities and our resulting readiness to identify fully with her choices.

THOMAS M. MESSER, *Director*
The Solomon R. Guggenheim Museum

New Images from Spain could not have been realized without the generous assistance of innumerable persons throughout its planning stages. Thomas M. Messer has acknowledged crucial contributions by organizations and individuals in his preface; I would like to add my expression of gratitude to the following:

The galleries in Madrid and Barcelona which generously devoted time to acquainting me with recent developments in Spanish art. In particular, the galleries Buades, Juana Mordo and Vandrés in Madrid; Ciento and Trece in Barcelona.

The critics and friends with whom discussions helped clarify my ideas concerning contemporary Spanish art: Juan Manuel Bonet, Paco Calvo, Victoria Combalia, Daniel Giralt-Miracle, Angel Gonzalez, Fernando Huici, Francisco Rivas, Rosa María Subirana; Luis and Carmen Bassat, Gloria Kirby, José Suñol, Rafael and Isabel Tous, Fernando Vijande.

Finally, those responsible for the documentation of the catalogue, a task which was carried out with exceptional perseverence and devotion: Karen Cordero, Blanca Sanchez Perciano and Philip Verre.

Of course, my sincerest thanks go to the artists themselves, for their uncompromising commitment to their art and their enthusiastic support of this project. And to the many staff members of this museum whose efforts and efficiency made the present exhibition and its catalogue possible.

M. R.

NEW IMAGES FROM SPAIN

MARGIT ROWELL

If we refer to the recent exhibition *Europe in the Seventies*,[1] we must confront the question that was posed there: does European art exist? Or is it "almost an American invention"?[2] In the context of Spain, this brings to mind other questions. Presuming that Spanish art does exist, does our ignorance of it stem from a historically determined situation: the relative isolation of the Spanish peninsula from the rest of Western economic and cultural development during the twentieth century? Does it derive from a kind of chauvinism which nourishes indifference to culture from abroad? Or is it due to a growing cosmopolitanism in which all artists are grouped in a single pseudo-nation and no importance is attached to native origins?

Despite prevalent views to the contrary, origins and environment are of some importance. It is a truism to assert that a country's culture is related to political, social, economic conditions, not to mention intellectual history and emotional idiosyncracies. Yet we cannot totally disregard this generality. An artist's relation to society is defined by the substance of the society within which he lives and works: its mentality, traditions, customs; its political framework, its social and cultural history, its economic priorities. An artist's relationship to the world at large is determined by his access to that world: the scope of information available to him.

In attempting to analyze the art of a country which is not one's own, these factors must be kept in mind. Studying an art means studying the milieu in which it emerged. Yet this is eminently dangerous. For each critic invokes his own social and cultural background in making his judgements. Whereas his knowledge is full and his instincts innate concerning his native context, they can only be partial in reference to a foreign culture. Thus, from the outset, we must recognize that our American perspective of Spanish art cannot be the same as the Spanish view of this same art.

The last exhibition of "contemporary" Spanish art selected by a major American institution was Frank O'Hara's *New Spanish Painting and Sculpture* shown at The Museum of Modern Art in New York in 1960, some twenty years ago. Even at that time, Spanish art was inadequately known abroad. Since then international exposure to Spanish art has been even more limited. Nonetheless, on the basis of quite fragmentary evidence, speculation has flourishd. Before attempting to examine the creative activity of the 1970s, therefore, it would be interesting to outline the discrepancies between the American perspective and certain realities of Spanish art over the past thirty years.

The American vision of Spanish art from the past few decades may be summarized briefly as follows: starting in the mid-1950s, Spaniards emerged on the international art scene with an impact which was extraordinary, par-

1. The Art Institute of Chicago, October 8-November 27, 1977, *Europe in the Seventies: Aspects of Recent Art*. Traveled to Hirshhorn Museum and Sculpture Garden, Washington, D.C., March 16-May 7, 1978; San Francisco Museum of Modern Art, June 23-August 6; Fort Worth Art Museum, September 24-October 29; Contemporary Arts Center, Cincinnati, December 1, 1978-January 31, 1979.
2. "A Letter from Rudi Fuchs," *Europe in the Seventies*, p. 23.

Antoni Tápies
Great Painting. 1958
Oil with sand on canvas, 79 x 102⅝"
Collection The Solomon R.
Guggenheim Museum, New York

ticularly in view of their noticeable absence from that arena since the Civil War. In 1956 Spain began submitting to international biennials major and significant selections by her artists, many of whom received honors. The sculptor Jorge de Oteiza and the painter Modest Cuixart won Grand Prizes at São Paulo in 1957 and 1959. In Venice Eduardo Chillida, Antoni Tàpies and Luis Feito were awarded prizes in 1958 and 1960. The presence of these painters and sculptors at such exhibitions gave rise to the idea that Spain was a liberal democracy where artists could create freely, and where their work was not only accepted but promoted by the government agencies controlling the selections to be sent abroad.

The Spanish art which won international prizes, although original, had certain affinities to art produced elsewhere. Spanish painting, mainly from Barcelona and Madrid, projected an expressionist and existentialist intensity comparable to that of Abstract Expressionism in America and *tachisme* in France. Like its counterparts in other countries, this art expressed the freedom and value of the individual human act in the face of a mounting tide of consumerism, industrialization and a progressively dehumanized society and environment. But even more significantly, to an outsider's eyes, this Spanish art seemed a revolutionary art; it was interpreted as a protest against the current political regime, albeit in abstract and somewhat elliptical terms.

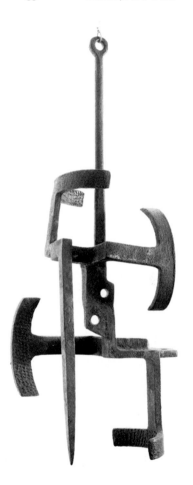

Eduardo Chillida
From Within. 1953
Forged iron, 38¾" h.
Collection The Solomon R.
Guggenheim Museum, New York

The most famous examples, from an American point of view, were Tàpies and Chillida (exceptional as a sculptor), Manuel Millares and Antonio Saura. Tàpies' seemingly irrational human gestures, his manipulation of natural colors and textures (signifying a return to essential values) appeared in this context to be a broadly political statement. Chillida's organic emblems in iron and wood, with their rough, hand-hewn qualities, were read in similar and vernacular terms. The naked violence and what was interpreted as an energy of despair in Saura's and Millares' tortured images, combined with their rejection of color (or predilection for black, white, sometimes red) were linked to a native past (for example, the *tenebrismo* of Goya), but at the same time seemed to manifest an untenable political situation specific to the present.

This generation was particularly visible during the late fifties and early sixties. The next phase of Spanish art appeared to express a reaction to informalism, a desire to be less subjective and more operational, and an awareness of Pop Art and the mass media which were symptomatic of the new generation's relationship to reality. At the same time an outside observer assumed that the political situation had improved, censorship had been relaxed and the artist felt free to express himself in more legible and explicit (that is, figurative) images. We may evoke Rafael Canogar and Juan Genovés whose only slightly veiled images of protest were presumably acceptable, since they too were sent to international exhibitions. A criticism of the Spanish political situation was still present, it seemed. However, this generation of the mid-sixties and early seventies stated its case more clearly, without ambiguity.

Yet, with a few exceptions, the artists of this era are already relatively obscure in the United States. For whatever reasons, the American stereotype of "Spanish" art remains that established by the previous generation: dramatically expressionist, richly textured, chromatically sober.

Therefore, the art emerging in Spain today is surprising. It is extremely eclectic, encompassing a broad range of styles, from realism to varied sorts of figuration, to geometric abstraction, to a kind of Color Field, to all manners of Conceptual Art (Land Art, Media Art, Body Art). One finds new materials, new themes, new subjects and objects, new processes and techniques, all of which appear to be developing in an atmosphere of total freedom.

If there is one common denominator in the more interesting and original art in Spain today, it is the ostensible lack of politicization. And so we conclude that this is the image of the new Spain; this is the definition of post-Franco art: an art-as-art expression.

The Spanish perspective, logically and naturally, is quite distinct from our own. Beginning with the generation of Tàpies, Chillida, Millares, Saura (our emblematic references to a group that included many more), two misconceptions have been perpetrated. The first concerns the fact that these artists did indeed live in an extremely conservative and repressive society against which they were in revolt through their underground cultural activities and their

Antonio Saura
Rioni. 1959
Oil on canvas, 63¾ x 51⅛"

Juan Genovés
The Window. 1975
Oil on canvas, 59 x 53⅛"
Private Collection

Manuel Millares
Dwarf. 1959
Oil on burlap, 63¾ x 50¼"

left-wing political position. Yet their artistic expression was political only inasmuch as they sought an alternative to the reactionary nationalist and traditionalist culture promoted by the regime. They sought to prove that art and culture must be free from political control and must not lose touch with the most essential and profound human values. Undeniably there was intensity and anxiety in the forms of the new art. But the supposition that its iconography embodied an explicit ideology of political revolt is false.

Many of the Barcelona-based *Dau al Set group*[3] were attracted to French Surrealism and, of course, were sensitive to its undertones of political subversion. Yet the Surrealists' real appeal lay in their notion of an art which drew on the subconscious and their technique of automatism, areas of interest to the concurrent French *tachiste* school as well. Elsewhere, in Madrid, Millares of the *El Paso*[4] group was drawn to American Abstract Expressionism. In view of the profound spiritual disillusionment in Europe and America after the Spanish Civil War and World War II, the recuperation of irrational and individual impulses as antidotes to an increasingly rational, mass-oriented society was general. It is therefore more realistic to say that the ultimate concerns of these artists were moral on the one hand and formal on the other, rather than expressly social or political. And if the works from this era are still meaningful today, it is because of their formal qualities.

The second clarification which must be made in this context is that the generation of the fifties, although they represented political opposition, were not persecuted for their artistic expression. In the mid-1950s Spain began to emerge from a period of isolation and, subsequent to new political and economic agreements with the United States and Europe, could finally encourage tourism and foreign investment. These phenomena forced the Spanish government to attempt to modify its image from that of a repressive dictatorship to one of a liberal democracy.

Hence, the regime's constraints on left-wing intellectuals became more subtle than they had been in the more openly repressive forties. For example, the artists who were sent abroad to represent a liberal Spain were given little opportunity to exhibit at home. In Spain the official circuit was the only circuit, and here the government exercised other criteria, selecting post-Cubist and late Surrealist artists for domestic consumption. Since there were few private galleries, few collectors or patrons, and literally no art press existed, there were no alternatives.

Everyone understood that an invitation to exhibit abroad, even though it involved a service to the Franquist government that was often incompatible with an artist's political convictions, represented a unique opportunity to show work. Moreover, by the late 1950s, artists and intellectuals were naively optimistic in believing that the regime's few overtures to the rest of Europe

3. Founded in 1948, *Dau al Set* included the painters Tàpies, Cuixart and Joan Ponç, as well as poets, philosophers and critics.
4. Founded in 1957, the artists of *El Paso* included Saura, Millares, Canogar and Manuel Rivera.

were signs of a liberalization and would be followed by progressive social change.

During the 1960s the relationship between the government and artists underwent a radical modification. Artists boycotted international exhibitions and all government-sponsored manifestations at home. There was a violent reaction against informalism, which was seen as the officially approved avant-garde. Exploited by the state for its own designs to project an image of liberalism abroad, informalism had also attracted younger artists who saw in its practice an opportunity to gain an international reputation.

By 1968, social unrest had reached a peak. Universities were shut down and the increased social awareness of Spanish intellectuals and artists led them to question the notion of an avant-garde expression which revealed itself to be useless and irrelevant, not only in terms of its abstract language (hermetically obscure) but its audience (capitalist, bourgeois and international) and its content (subjective, irrational, individualistic and without social commitment). Spain's growth as a capitalist economy and the influx of foreign information merely confirmed the political left in its perceptions of the repressions and effects endemic to a capitalist state: imperialist wars, political assassinations, social inequalities, police brutalities.

This complex political situation and the social consciousness of Spanish artists gave rise to two formal directions, both developed in reaction to informalism. Each tendency represented a call to order. The first was a form of geometric abstraction, known in Spain as *racionalismo, arte analitico* or *arte normativo*. The connotations are clear: rationalism, objectivity, anonymity. As in earlier twentieth-century variants of geometric art, the goal was a new pictorial language to express an ideal of harmony and order, an order which could be integrated into the social and visual fabric of modern life. Yet it soon became clear that even when extended to the design of everyday objects, this language was inaccessible to the people; and the ideals referred to an abstract utopian notion of human society rather than a concrete, historically-determined social situation.

The second dominant movement of the sixties—*nueva figuración*—addressed itself directly to the situation at hand. It was comprised of several kinds of figuration, one of the more original of which is described by the term "critical realism" and represented by artists such as Canogar, Genovés, Eduardo Arroyo, *Equipo Crónica*.[5] These artists and many others attacked the capitalist world at a variety of levels through the microcosm of Spain. They criticized political situations and consumer society by evoking familiar incidents and objects, symbols and myths. They focused on specific national problems and refused to let themselves be promoted by the regime.

These artists strove to create an art that was direct and uniquivocal in content and language. Their precedent was the *Estampa Popular* movement

5. Two Valencian artists who have collaborated since the early 1960s on paintings and sculptures, signing themselves "*Equipo Crónica.*"

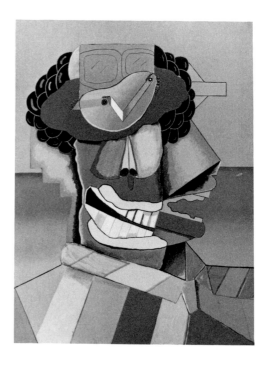

José María Yturralde
T-26. 1972
Acrylic on wood, 67⅜ x 77½"
Collection the artist

Luis Gordillo
Male Head. 1973
Acrylic on canvas, 63 x 47¼"
Collection J. Suñol, Barcelona

Eduardo Arroyo
Search in St. Sébastian. 1967
Oil on canvas, 44⅞ x 58¼"
Collection Peter Selinka

Equipo Crónica
The Living Room. 1970
Acrylic on canvas, 79 x 79"
Collection the artist

of the late 1950s and early 1960s. This was not a school based on a single style but a group of artists of many formal persuasions who banded together to make prints which would be conceptually and economically accessible to all sectors of the population. Taking their inspiration from German Expressionism and the art of the Mexican Revolution, they produced inexpensive, clearly political woodcuts and linocuts in large numbers. They wished to subvert the idea that the fine arts were unique, expensive, arcane and therefore reserved for the educated classes.

Estampa Popular was not particularly successful because its exhibitions were limited to the traditional fine arts circuit and the prints did not reach the inclusive population for which they were intended. Yet the experience was fruitful for many artists in that they became aware of the resources of popular or familiar imagery as well as the impact that a simplified visual syntax could obtain. Much of this experience would be translated into the new vernacular of *nueva figuración* whose professed aims of clear, direct communication were identical.

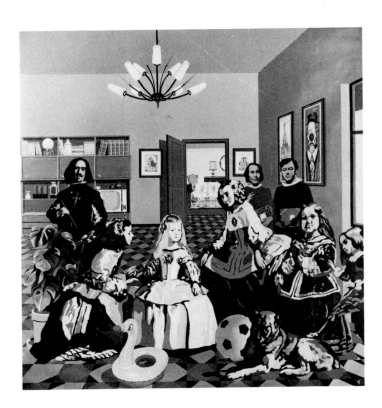

Simultaneously, the generation of the sixties discovered Pop Art. But in view of their cultural isolation and political commitment, the Spaniards' relationship to Pop Art differed from that of artists in other European countries. In the first instance, Spanish artists' exposure to Pop Art was usually secondhand, obtained either through black and white reproductions, written descriptions or word of mouth reports. In other words, it usually reached them through the media. If one considers that a basic raw material of Pop Art is the media image which is translated by a specific subjectivity into a language of artistic conventions, it is interesting to observe that by the time this art form arrived in Spain, it had been reconducted into a secondary reproduction or media image. Second, Spain was less media-dominated than most of her European neighbors. And Spanish artists' training was still extremely academic. So that the media stereotype as a new material impressed Spanish artists more than its particular transformations.

As we have mentioned, these artists sought objectivity and communication above all else. The photographic or otherwise reproductive image provided them with a medium at the opposite extreme from that of the accepted avant-garde of informalism: it had no texture, no subjective handwriting, no abstract images or elliptical signs, no aura of sacredness. Their new technique would be a *decontextualization* and assemblage into new images of cultural myths and hallowed artistic styles, thereby provoking a new awareness or questioning of accepted values. The exposure to Pop Art was extremely operative, producing results germane to the Spanish situation. Because an important aspect of Pop Art is its challenge of the entire meaning, function and language of the "fine" art idiom. In bringing the artist's activity to the borderline of commercial art, it forces the invention of a new set of criteria for judging works of art. This corresponded to the politically-grounded ideals of the new generation of artists in Spain. It helped them develop a vocabulary and syntax appropriate to their political, social and intellectual concerns.

These artists did not wish to be promoted through the official circuits. Fortunately, by the late 1960s and early 1970s private galleries and patrons began to lend their support to the new generation. Spanish art was seen in neutral public places or in private homes, foreign critics traveled to Spain, and these critics and private dealers from abroad began to bring out Spanish art. International exhibitions—no longer considered prestigious and political showcases—asked international juries of critics to review national selections, thereby providing more objective points of view.

The generation of the 1970s shares certain preoccupations with its immediate predecessors but does not include political content in its art. Most of these artists are socially concerned and many are members of the Spanish Communist party (PCE), but this commitment is not reflected in their work. At first glance, the art looks more innocent than that of the previous generation. It seems detached, freely imaginative, optimistic. In actual fact, perhaps these artists are less ingenuous. Experience has revealed the pitfalls and futil-

ity of an *engagé* art which can easily be exploited to ends antithetical to its commitment. The younger artists are aware that art does not change the world nor does it even reach the masses. It is perhaps the first generation for a long time which does not feel pressure to express some political commitment in its work.

Yet the rejection of the authority of the international avant-garde continues nonetheless. And this is an important consideration in the appreciation of Spanish art today. This rejection is not based only upon ideology; there are practical and economic considerations as well. To begin with, the definition of the avant-garde has changed. If at the outset the term was reserved for a minority, today its aesthetic standards are set by an international majority. A logical sequence from one aesthetic development to the next, traced by critics, art historians, collectors, patrons and museums, establishes and imposes a reassuring continuity of styles. However, the Spanish peninsula, due to its history and geography, has been isolated from the official sequence of avant-garde movements for several decades. Its artists have only participated sporadically and accidentally in the international mainstream and have not produced the same impact or reflected any of the same logical continuity at home. Information about foreign movements is sparse and secondhand. Foreign art books and periodicals are still largely unavailable today. Exhibitions of artists from abroad are rare. Works by foreign artists are not collected by the few museums of modern art in Spain.[6] And the fragmented information that does exist is disparate and meaningless in a country whose twentieth-century history is parallel to but separate from that of the rest of Europe. As a result, the Spanish artist's creative life is peripheral to the international mainstream.

Second, the rules of the avant-garde today are determined in no small way by a buyer's and seller's market. But an art market as it exists elsewhere is not a reality in Spain. An art market which imposes demands, dictates public taste, deals out critical or financial acclaim at an international level, is almost an abstraction to many Spanish artists today and, as a result, it is not a priority. This is equally true for many Spanish critics and collectors, for whom the *succès d'estime* counts as much if not more than the *succès commercial*. Spain is perhaps one of the last countries in which this distinction is sustained.

Therefore, the Spanish artist is less self-conscious than others regarding a competitive market system, with its imperious aesthetic and economic value scales. The incomplete nature of information from abroad and its lack of meaning in relation to his own context forces him to rely on the resources his country can offer: his past and present, his emotional and conceptual experience, his physical environment and cultural traditions, and accessible knowledge, even if only fragmentary. This creates a restricted universe of material which

6. On the subject of museums of contemporary art in Spain, their history and collections, see Rosa María Subirana, "Museos y Centros de Arte Contemporáneo en el Estado español," in *Batik* (Barcelona), no. 35, June-July 1977, pp. 41-47. It is worth noting in this context that some artists of an older generation have sought to perpetuate the lack of exposure to foreign art in Spain in order to maintain their own authority.

must suffice. And his own subjectivity and imagination which sort and filter are his only guides.

In one sense, today's Spanish artist is in an enviable position. He is not psychologically competitive or economically oriented. Since information from the outside is a minor and marginal coefficient in the equation that defines his art, he does not risk becoming derivative of the international avant-garde. Because no market exists at home, the artist is in a position to generate one — forge his own criteria and form his audience and critics. And the historical conjuncture of theoretical, political and economic freedom (despite rampant inflation) is favorable. So that paradoxically, isolation, often a handicap in Spanish history, may offer an advantage to this generation.

POETIC REALISM: TERESA GANCEDO

In today's international art world, true realism is not avant-garde. From the Spanish perspective, in some ways it is even more traditional than elsewhere, because it has existed for so long, at least since the sixteenth century when Spanish and Flemish painting shared many common characteristics. Although certain styles of realism have lately come again to the international vanguard scene — in the forms of Pop Art, Hyper-, Sharp Focus-, or Photo-Realism — a tradition of muted, near-literal realism, not comparable to these, has pursued its uninterrupted course in Spain for several decades. In a way, it is a separate, parallel tradition, represented today by its strongest and best-known exponents: Antonio López-Garcia, Julio Hernández, Carmen Laffon, Francisco López and others.

The work of Teresa Gancedo, the artist closest to a realist tradition in this exhibition, is a strange and personal synthesis of modernist concerns and this tradition of realism, and is thus unassimilated and marginal to both. Gancedo's realist affinities are seen in her subject matter and her technique. Her subjects are taken from the age-old traditions of a Catholic country (she is not a practicing Catholic and feels these motifs belong to popular rather than religious customs pertaining to the ritual celebrations of life and death). Although images of death dominate her most recent paintings — the reliquaries, cemeteries, mortuary wreaths — death for Gancedo is not frightening but natural. Perhaps it is the extreme moment of revelation of the meaning of life. She also draws on nature: birds and reptiles, trees and flowers at different stages of their life cycles: egg, embryo, skeleton returning to dust; bud, flower, dead denuded branch.

Gancedo's technique is also related to a realist tradition. Often her point of departure is a photograph from a magazine or newspaper, which may be reproduced as is (through photo emulsion directly on the canvas), or handtinted. Sometimes she makes objects (of wrapped twigs, for example) which she attaches to the canvas, or she copies in perfect renderings. Her drawing

Antonio López-García
Icebox. 1968
Oil on wood panel, 47¼ x 57⅛″

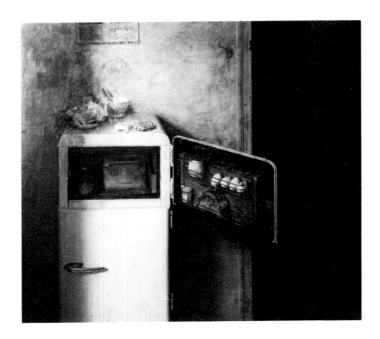

is precise and immaculate to the point of trompe-l'oeil. Each formulation is a different transcription of reality.

Despite these distinct and faithful translations of real objects, the results are situated at a level other than reality itself: because the artist's reality exists in a time-frame very different from that of our everyday lives. Whether the objects are isolated in sequential compartments, organized according to a grid structure or freely dispersed over the flat surface of her support, they are severed from the time and space of their original context and are also foreign to our own lived experience. Occasionally blurred by a uniform faded wash or clouded glass panes, they seem to be filtered through the artist's personal memories and redistributed according to her own sense of time: past, present, possible or undefined. Thus they cannot be read according to the automatisms of ordinary perception (from close-up to depth or from whole to part, for example). Because we are forced to follow a linear or circular discursive sequence we must shift from one level of reality to another, thereby encountering different physical, spatial, temporal, perceptual, tactile experiences.

So that if Gancedo's vocabulary derives from a realist tradition, her syntax — the alternate or simultaneous uses of the grid, narrative sequence, repetition and rhythm, or even an allover emphasis — shows an awareness of strictly contemporary formal preoccupations. As a young artist she was attracted to López-Garcia for certain aspects of his realism: a magical intimacy

in his approach and the mixture of reminiscences and present reality; and to Tàpies for a mystical relationship to reality, seen in his abstract concept of space, his mysterious transformations of concrete materials and "floating" objects (unanchored in reality, even though tactile entities).

Although we can understand the logic of her affinities, Gancedo's discourse on reality expresses a highly idiosyncratic vision and method, a subtle emulsion of subjectivity and objectivity, which cannot be assimilated to either of these modern traditions.

EXPRESSIONIST BAROQUE: DARÍO VILLALBA

Aesthetically, Villalba belongs to the second postwar generation. But his art proves that superficial distinctions, based on immediate impact or partial knowledge, do not remain valid under scrutiny. Villalba's work has been compared to the critical realism of Genovés and Canogar, artists who ostensibly repudiated informalism and attempted to make more direct political or social statements.

Yet it is important to isolate the aspects of informalism which were unacceptable to the subsequent generation. These were, in particular, its abstraction, its manipulation of crude materials and its individualistic expression. The artists of the next generation, while they sought a solution in more anonymous figuration—often inspired by or borrowed from the media—did not abandon the chromatic sobriety, the attention to materials (although different materials) and the underlying expressionism and moral implications of their predecessors. They did not reject informalism out of hand, only some of its more obvious characteristics.

Villalba has chosen photography and plastic as his materials, not only as a result of his exposure to Pop Art but because they correspond to the reality he seeks to depict. His reality is that of the human condition in the modern world, a condition of estrangement in a technological environment. The artist's particular focus is alienation, as producing acute physical or mental pain (sickness or madness), and leading to hospitalization, imprisonment or other forms of ostracism from human society. Yet the isolation and psychological suffering are as intense for those who continue to live in society. So that Villalba's subject matter—essentially fugitives or victims of society—are paradigms of our own existence.

Photographs, as objective representations of living beings, divest human figures of warmth, mobility, expression, emotion, and translate them into clinical records. For Villalba, photography is the ideal medium through which to abstract highly-charged emotional images. Yet he compensates for the loss of human vitality by silhouetting and enlarging these mechanical images, thus intensifying the helpless solitude of his subjects.

Through much of the 1970s Villalba encapsulated his iconic silhouettes in plastic bubbles. The figures, free in space, are in fact entrapped within invis-

Juan Genovés
On the Ground. 1975
Oil on canvas, 33½ x 39⅜″
Private Collection

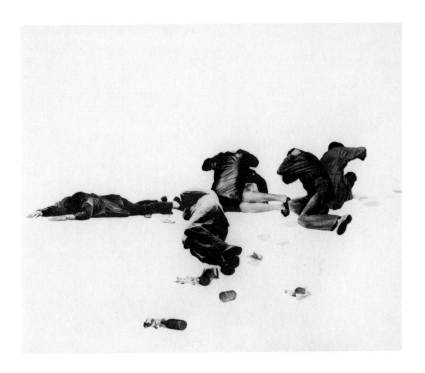

ible walls, suffocating, separate. Hanging from a frame, they may be pushed or played with, a further allegory of their victimization. So that photography and plastics, despite their Pop Art origins, are not used to evoke the anonymous banality of our consumerized lives but to remind us of the existence of other values from which we have isolated ourselves.

Paradoxically, the use of technology humanized the artist's concept and heightened his expressionism. Although Villalba at first did not manipulate his photographic images (for him these figures were "untouchable"), his choice and framing of subjects conveyed his precise feelings. The most recent work reveals the artist's desire to participate more actively, to identify, rather than remain intimidated or aloof. Obscuring certain details, totally obliterating others, adding crude tense gestures which accentuate the contained emotion (instead of showing the artist's real compassion), he arrives at a more mysterious but no less powerful statement.

These recent paintings reveal a nostalgia for Abstract Expressionism (an avowed affinity) and the more European form it took in *El Paso*. In this work we may speak of a baroque sensibility in which aggressive physicality and a kind of compassionate mysticism fuse in an image of violent oppositions and vitally expressive motifs.

SUBJECTIVITY/OBJECTIVITY: MUNTADAS

Villalba's baroque expression, despite its borrowing of images and techniques from the Pop idiom, is nonetheless close, in its humanistic preoccupations, to the art of the fifties. Both are existential, moralizing and draw on the irrational of both artist and viewer. But what is the subjectivity of our time? The generations of the sixties and early seventies were usually more sceptical than their predecessors, maintaining that there is no subjectivity but rather a pseudo-subjectivity shaped by an invisible although pervasive ideological context. The goal of the critical realists, for instance, was to dismantle the system of hidden mechanisms which controls and directs so-called subjectivity.

Some artists (such as those of *Equipo Crónica)* sought to subvert the ideological framework through the medium of art itself. They borrowed their visual vocabulary from the media and from earlier, established avant-gardes, displacing or decontextualizing it so it could be seen for what it was and no longer as an unquestioned, untouchable cultural symbol. They provoked a new look at art, at cultural values, at the automatisms of perception; at the relationships between culture and society, between art and politics. Others, like Muntadas, felt obliged to choose different visual means which, although generally accepted, were less culturally sacred and paralleled or illuminated the conditioned responses of the aesthetic experience.

For Muntadas the traditional art experience is marked by passivity: the viewer does not participate, he receives. Further, the art object has become a marketable product and a symbol of social status. Like many artists of his age, Muntadas attempted to escape the closed circuit of commercialized value systems and make works of art which incite a participatory and critical response and are thereby socially useful.

The landscape of twentieth-century man is a landscape of information processed by the media. It is presumably factual (in contrast to art), and we do not question its objective neutrality. But the media, as the word implies, *mediates* information. The anonymous (or identifiable) people "behind the news" are *selective.* In this they are no different from the nineteenth-century painter who selected and modified his motifs in the process of preparing his landscape. In both cases ideological premises color the subjectivity which filters facts according to conscious or unconscious priorities.

Muntadas' goal is to demythify the notion of objectivity by attacking the circuits of public communication. By extension this leads to a questioning of the concept of personal freedom upon which our societies are built: freedom to respond to outside stimuli, freedom to process information, freedom to act or be. He also shows us that we are prisoners, not of a given society, but of unconscious ideologies. Muntadas focuses "between the lines,"[7] on the distorting mechanisms that change what is real into what is offered as real, and on the commitments which direct these mechanisms.

7. The title of a project by the artist, February 1979.

Muntadas
Subjectivity/Objectivity:
Private/Public Information
Brochure for video presentation,
The Museum of Modern Art, New
York, April 3, 1979

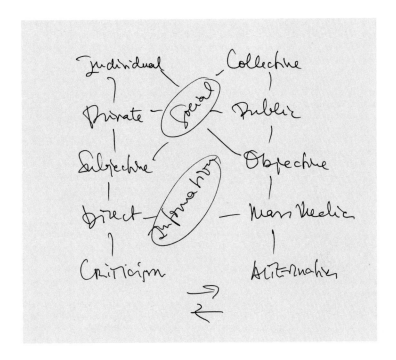

He uses the media to dismantle its own image. A videotape shown on a television monitor puts the viewer in the same psychological state of passive receptivity as that engendered by commercial television. Yet when Muntadas reveals how the television synopsis is made and what is discarded, the viewer realizes that the information has been processed into selected symbols which betray the total factual fabric. He realizes he has been manipulated. And, although the demonstration proves that neither he who makes the news nor he who receives it has any personal freedom, an awareness of this erosion of reality can produce more active critical attitudes.

Since Muntadas is Catalan by birth, he has firsthand knowledge of ideological manipulation. The Franquist regime was particularly repressive in Catalonia, banning the Catalan language in schools and printed and spoken media, attacking all other aspects of the Catalan national culture and identity and substituting an all-powerful centralized, conventionalized (and by Catalan standards, meaningless) propaganda. Probably for these reasons, there is more politically oriented and conceptual art in Barcelona than elsewhere in Spain; and no doubt for the same reasons, Catalans form the majority of Spanish expatriates. Yet if Catalonia is an extreme example, it is not unique. A strong contextual ideology is the spiritual and practical basis of all human societies.

In his most recent project, *Pamplona-Grazalema*, Muntadas (in collaboration with the social anthropologist Ginés Serrán Pagán) examines the origins of the ancient rite of the bull in Spain; how historical conditions can deflect and distort the connotations of a symbol and how this symbol is used as an ideological vehicle in two distinctly different social frameworks. This collaborative venture—an interaction of two subjectivities made up of different backgrounds, knowledge and perspectives—represents the only possibility of approaching objectivity.

ORGANIC GEOMETRY: SERGI AGUILAR

Sergi Aguilar's recent sculpture is a synthesis of conflicting premises. His forms are at once rectilinear and organic, geometric and fluid. Executed in black Belgian marble, their density and weight are manifest; at the same time, their scale is intimate and certain configurations tend toward the two-dimensional or pictorial.

Modern Spanish sculpture until the present generation has explored two distinct directions. The earliest and probably most indigenous is represented by Oteiza (unfortunately little-known in America) and Chillida. It is gestural, organic and crudely forceful, and presumably refers to the products and tools of the ancient Basque tradition of wrought iron. The second, less well-known and perhaps less original, embodies the more recent concepts of *arte normativo, analitico* or *racionalisto* and is exemplified in the sculpture of Andreu Alfaro. In the first, the material is significant and dictates the forms; in the other, the material is secondary to the abstract concept and image.

Aguilar's earliest sculptural activity obeyed an abstract geometric aesthetic. Perhaps this formulation appealed to him in the late sixties and early seventies as a way of rejecting the image of the avant-garde Spanish sculpture promulgated for consumption at home and abroad. Yet Aguilar looked to abstraction not as an expression of "rational" premises, but for its formal purity. Brancusi was an early influence as a paragon of pure form as well as for his attention to the specific properties of materials. The Russian Constructivists were important for analogous reasons. Yet, starting around 1975, Aguilar began to examine natural forms—twigs and branches, for example—which escape rationalization because we can neither control nor explain their vitality. His idiom today is a combination of abstract and organic forces.

One would be tempted to define Aguilar's recent sculpture as a kind of organic Constructivism. But this is an approximation. His respect for materials may derive from a Constructivist aesthetic. This consideration is seen in the low-lying silhouettes of many of his pieces which express the weight and density of his mediums. Further, the two-dimensionality of much of his work evokes a planar tradition in sculpture which originates in Cubism and Constructivism. The notion of pictoriality is heightened by polished surfaces which emphasize planes and by drawn incisions and precise flat areas of light

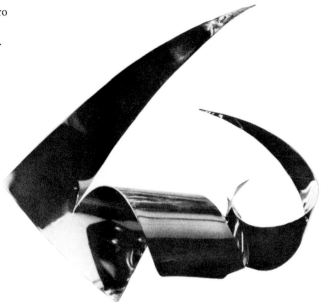

Andreu Alfaro
Dawn. 1962
Iron, 17¾" h.

and shadow. The concept of a dialogue between closed mass and open space, visible in his sculpture, is also Constructivist in its source. Articulated units are usually carved from a single block; the immanent presence of their matrix imposes a spatial continuum. The surrounding space is part of the work, and the fact that elements of certain sculptures may be moved apart, opened or closed, allowing light and air to enter, explicitly reinforces these spatial concerns.

Yet stone and marble are not usually identified with the language of Constructivism. Although Aguilar respects his materials to a point, he forces their potential into unpredictable forms, diverting them from their original destiny. Nevertheless, the integrity of the material is not violated. It speaks for itself but in a different voice. Thus, a contradiction between natural and cultural forces is constantly visible. One might expect these forces to be mutually destructive, creating a strangely dissonant formal hybrid. On the contrary, each reinforces the particularity of its opposite.

Much modern sculpture relies on new mediums and materials such as plastics, polyurethanes, strident colors, found objects, or attempts to transgress the traditional boundaries of art, dissolving mass into void or translating abstract ideas into concrete forms. Aguilar's sculptures, which are mediated but not rational, organic but not expressionist or gestural, the formulation of plastic concerns rather than abstract ideas, stand aside from the mainstream of contemporary sculpture.

PINTURA-PINTURA: JORGE TEIXIDOR

From an American perspective, a Spanish Color-Field painter seems to be a contradiction in terms. Where is the texture we associate with Spanish painting? Where are the gesture, the aggressive color contrasts, the images (abstract or Surreal or blatantly political)? Teixidor was probably aware of the Spanish stereotype, and his art, like that of other members of his generation, was a conscious or unconscious attempt to break the hold of that image.

Teixidor belongs to the generation which discovered Pop Art and found in it an alternative to native idioms. Although he was never a Pop artist in any sense of the term, the formal innovations of the style were important for him, providing a less provincial and more concrete starting point for his evolution. In Valencia the threat of provincialism was strong. Furthermore, when artists did revolt against the excessively academic training of the Valencian Escuela des Bellas Artes, they usually pursued one of two directions: *arte normativo* or geometric abstraction, introduced in the 1950s by the groups *Parpallo* and *Equipo 57*; or figuration, which dominated Teixidor's own generation and was particularly aggressive in the circle around *Equipo Crónica*.

Teixidor's itinerary is meaningful because it is exemplary for an artist of his generation. Turning his back on informalism, his initial impetus came from more concrete, less mystical and less specifically native painting styles. Yet, whereas Pop Art and geometric abstraction provided formulas for challenging the limits of painting, they offered no means for development within those limits. So that Teixidor finally returned to a primary dialogue with nature, process, color and space.

The subsequent canvases are based on a plastic vision that is free of the mediation of conceptual premises. In the early works of this series, Teixidor drew his inspiration from nature—close-up photographs of details from landscape—in order to capture an abstract morphology which he translated with a loose brushstroke and an indistinct modulated, milky chromatism. These paintings are allover in the American sense; yet the presence of almost invisible horizontal or vertical lines endows them with an implicit man-made structure or architecture which removes them from their original naturalistic source. These linear tracings, perhaps a holdover from the "constructed" spaces of his earlier works, also create an ambiguous spatial milieu: the viewer is simultaneously conscious of the physical presence of surface and of illusory depth.

Teixidor's painterliness is not unique in Spain—if it were, his experience might be less significant in the context of this exhibition. Older artists have been exploring this direction as well: José Guerrero, who has lived mainly in New York since 1949 and Rafols Casamada of Madrid come to mind. Increased access to information has induced younger artists—for example, the *Trama* group in Barcelona—to attempt to work within the limits of a painterly tradition.

Color-Field painting, although respected abroad, has had fewer disciples or outgrowths than other American-based artistic movements. This circumstance presumably stems from the movement's origin in a peculiarly American sensibility, untrammelled by tradition and characterized by particularly free concepts of space, technique and color. It is a pure painting experience, an art-as-art experience, and has no secondary subject matter to reassure the viewer. Recent European attempts to expand upon Color-Field painting—for example, the French *support-surface* artists or the above-mentioned *Trama* group—have therefore depended upon a vast theoretical framework and much prose to make it palatable to a public initially unsympathetic to its premises. Thus Teixidor's experience is in some ways unusual. He came to his personal solution through an instinctive need to extricate himself from the intellectual games of geometric abstraction and to address the specific issues of pure painting. He made his transition by exploring the problematics of Monet, Matisse, Rothko, which ultimately led him back to natural light, natural color, natural space. He does not rely upon theorizing to make his work acceptable. As painting, it must justify itself.

EGO: ZUSH

Extreme Catalaneity and acute schizophrenia are the first impressions produced by Zush's paintings, drawings and books. Catalan traits are most immediately evident in the apparent inspiration from the occult, embodied in the supernatural, phantasmagoric figures which have been a constant in Catalan art since the Middle Ages. We find recent examples of these motifs in Miró's "magic-realist" period of 1923-24 and in drawings and paintings by Barcelona's *Dau al Set* group, particularly in the work of Joan Ponç and Modest Cuixart. It may also be argued that specific leitmotifs—frogs, lizards, snakes, snails and bats—derive from Catalan Romanesque bestiaries, and the isolated eyes of supernatural vision perhaps recall those found on the wings of medieval seraphim. The miniaturization of forms and flat, acidulated hues provoke further reminiscences of Catalan manuscripts.

Catalaneity is also presumably expressed in the jagged energetic signs of Zush's cryptic alphabet. A secret code which can only be deciphered by initiates, it conjures up associations with the cabala. The emphasis on graphic gestures as vehicles of vitality, of metaphysical anxieties and simple pleasures, as enigmatic signs of the magical and the real, occurs also in the oeuvre of Miró, Tàpies, Ponc and Cuixart.

The rich accumulation of these elements, motivated by a sort of *horror vacui*, produces the effect of a schizophrenic art, sophisticated to be sure, but close, tight, obsessional and disquieting nonetheless. Schizophrenic drawings are an extension of self, without critical distance, objectivity, control, without a will to communicate.

Modest Cuixart
Drawing for *Dau al Set*

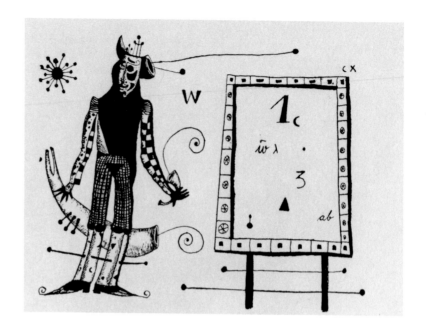

Although all of these components are present in Zush's art, one must speak here in terms of analogy rather than of direct references. Zush is a child of the 1960s. His major influences were Pop culture, drug culture, psychedelic experience. His knowledge of English gave him access to Burroughs' world; he understood The Beatles—their music which rocks the senses and their lyrics which defy the rational structures of discourse—and he understood their sources. He hallucinated, and this revelation of other dimensions of human experience, alternate kinds of space and a new world of images, gave him another sense of himself and the universe.

When Zush discovered the poetry and iconography of *Dau al Set*, these forays into the unconscious were already familiar. But they did not go far enough. Furthermore, hallucinations were not a means of escape from a political situation but from a society in which he felt completely alien. Yet, he did not feel threatened by contemporary or Pop culture; on the contrary, it was his element. He did not wish to understand the mysteries of the legendary metaphysical world, but to understand his own cosmic consciousness. So he had no reason to look toward traditional mysticism or the art of the Middle Ages; he found his images and their interpretations in his own childhood, his fantasies, his hallucinating subjectivity.

Zush's real space and his pictorial space are mental space. In the paintings, his space can be extremely open, inhabited by floating forms (which in fact are intricately articulated like an astronomical constellation). Or it can be narrative or sequential. Sometimes it is frontal; sometimes it retains vestiges of symmetry. It is never natural, logical, rational, stereometric or perspectival. In many of the drawings the space tends to be close, filled by a tightly-knit fabric of signs. His art manifests a primitive and childlike relationship to the world, a relationship without distance. Although they are not clinically schizophrenic, these works are indeed obsessional.

Zush's iconography is centered unashamedly around his person as a focal point for the only cosmic order he will ever truly apprehend. His images signify friends, feelings, events, fantasies, a private world of definitions, a personal mythology. His alphabet and handwriting were invented for his own use and pleasure. Drawing fundamentally on his subjective experience, Zush's purpose is to mediate the insights he has gained to the world at large.

So that this art is at once introspective and sociable. One would almost be tempted to term it exhibitionist. For the artist delves into his most intimate experience and shares it with his audience. The *ego* is the subject matter, but as a microcosm in a world of *egos*. Zush's enigmatic signs, formulated in a clear and articulate visual language, confront us as vivid and evocative images of universal desires.

POST-MODERN PAINTING: PÉREZ VILLALTA

Post-modernism in architecture is superficially described as nostalgic, eclectic and decorative. It not only challenges the noble notion of the avant-garde (as a looking and moving forward) but also repudiates the conventions of seriousness, originality and good taste traditionally identified with high culture. To its critics, this architecture is blasphemous, reactionary and déjà vu, shocking, displeasing, disconcerting. Pérez Villalta's painting is amusing, ornate, electic and confusing. It is loaded with nostalgic and contradictory references—both thematic and stylistic—to other times and places. Its forms are distorted, its colors are dissonant. The space defies analysis; the content seems at once rhetorical and mundane. Perhaps we may conclude that this is an example of post-modern painting.

Pérez Villalta belongs to a generation which has chosen to disdain openly and explicitly all the avant-garde purports to honor. Rather than predicating the future, he explores the past. He prefers figuration to abstraction and assimilates kitsch, Art Deco and all forms of popular culture without excusing himself. He dares to be subjective, even autobiographical. He discards social consciousness. His is a knowing and ironic comment on the fallacies and vanities of the avant-garde as we understand it. Yet in so doing, he attempts to reassess the possibilities of a traditional pictorial language stripped of all established

clichés. And thus his peculiar discourse is an elusive investigation of the very codes of painting.

Pérez Villalta's central concern, often highly visible, is the "impossible combination," or the fundamental and unalterable contradiction. At the most obvious level this is apparent in his adoption of thematic and stylistic material from the past which he elaborates in an idiom emphatically of the present. It is further seen in the casual juxtapositions of good and bad taste, of modern and ancient symbols, of realism and abstraction. In a more general but more subtle manner, it is expressed in the extremely deliberate construction of his canvases and seemingly irrational space thereby generated. For example, many of his paintings, such as *In Octu oculi* and *Ecstasy During the Siesta* are composed according to a rigorous grid system. Yet the disquieting, spatial milieu produced triggers an emotional rather than a rational response.

The artist's themes are subjective. They reenact his real and fantasy life, his intellectual, emotional and aesthetic experience. A key theme is the "impossible combination" of the European and African worlds, a contradiction fundamental to Spain. This dichotomy is particularly crucial to Pérez Villalta's own experience because he comes from Tarifa, the southernmost tip of Spain near Gibraltar—the gate between the Atlantic and the Mediterranean. In this part of Spain, the attractions of the rational and the irrational, the abstract and the real, classicism and romanticism are equally powerful.

In the *Annunciation* or *The Meeting*, the artist has taken a classic pictorial theme and interpreted it according to his own vision. On the left, the man (traditionally the angel) enters the scene from the outside. His universe is that of reason, creation, the spirit, enhanced by the appropriate symbols: a fruit tree, paper and ink, a palette. It is a world of Cartesian clarity, expressed by a coherent perspective with infinite and logical transitions, cool muted colors, a gray hazy light. The woman's universe on the right is a closed egocentric and introverted sphere, where the acts and symbols relate to her own body: a mirror, a piece of fruit and a chess set for her reflection, consumption and diversion. The colors are harsh and bright, the depth is limited, finite. The two panels are separated by an imaginary space, bounded on either side by Avila and Calpe, the pillars of Hercules, the gates to each world.

The Studio, inspired by Velázquez' *Las Meninas* and an interior by Vermeer, presents the same contradictions, although concentrated in two metaphors of landscape. While no longer dominant, the theme is treated once again in *In Octu oculi*, which refers to a painting by the same name by the seventeenth-century Sevillan painter Valdés Leal. The primary subject is the instant of revelation of life's mysteries or the passage from childhood to adolescence.

Neither Pérez Villalta's themes nor his inspiration can be considered particularly original. The thematic references are classical; the stylistic allusions and many motifs and symbols are also eminently familiar. Yet the images have been mixed and reordered as in a kaleidoscope, according to an original spatial

vision, producing an impression of the fresh and unfamiliar and eliciting an unforeseeable emotional response. The impossible combination of realism and abstraction occurs here in a post-modern synthesis.

AN ARCHEOLOGY OF PERCEPTION: CARMEN CALVO

The city of Valencia is somewhat isolated—geographically, economically and culturally—from the main circuits of artistic activity, both in Spain and abroad. As noted earlier, the dominant tendencies in this area from the late fifties to the late seventies were geometric abstraction and critical realism. Miquel Navarro and Carmen Calvo belong to the generation which felt the impact of Valencia's *Estampa Popular* and *Equipo Crónica*. Although their work does not appear on the surface to express social consciousness, perhaps it more clearly approximates than any other young Spanish idiom the goal of the former avant-garde: an art which, through its opposition to the established academies, aspires to change existing social values and inequities.

Both Calvo and Navarro worked for short periods with *Equipo Crónica*, and this experience surely colored their approach to art. Both have also worked in ceramic factories in Valencia, a city famous for its pottery production since neolithic times. So that when they abandoned painting to adopt ceramics as their expressive medium, their choice was rooted in personal experience and convictions. Because manual skills are held in high regard in Valencia—primarily an agricultural and industrial region—this reinstatement of a craft technique should not be interpreted as an anti-art gesture, but rather as a viable yet unvalidated alternative. However, in blurring the distinctions between fine art and popular craft, they also express their deliberate rejection of the artificial laws of the commercial market and a desire to redefine the work of art, the artist's activity, his role in society and the art public.

Thus Calvo's ingenuous landscapes are motivated by a certain social consciousness. Her process (of forming, firing, breaking, coloring and sewing or gluing clay pieces on the canvas) and her unconventional materials (clay, but also chalk, pottery shards, glass and others) are similar to those of the craftsman. Despite the importance of the manual labor associated with these works, however, her formal references are artistic and cultural.

A crucial component of *Equipo Crónica's* critical realism is the decontextualization of formal and thematic material from the consecrated models of art history. Similarly, Calvo's overt reference to French Impressionism (seen in such works as cat. no. 13) is ironic and critical. She translates the quick, short strokes of Impressionist brushwork into handmade and hand-colored "strokes" in clay. After atomizing the elements of relief, color, play of light (all Impressionist concerns), the artist aligns them like archeological specimens on a canvas, thus destroying the mystique of individualism and temperament related to Impressionist painting.

For Calvo's contemporaries, the informalism of the fifties was still the official avant-garde model, and she was sensitive to its gestural expression and natural materials. Yet, like other younger artists, she felt compelled to order and reassess existing cultural materials and to recast them in the vernacular of her own time.

Calvo is fascinated by archeology as a system of classification. Although she may be influenced by its example, her own system of classification is arbitrary, spurious, dictated by her personal vision, articulated by her personal rhythms. Pre-existing modes or motifs of painting are her subject matter; she isolates and translates these subjects into concrete artifacts, compiling them into anthologies or repertories of plastic signs which project a new image and meaning.

The result is a comment on the painter's means and ends, developed in relation to the artist's roots and experience. In its visible contradictions—between painting and relief, past reference and present reality, freedom and rigorous classification—as well as the more fundamental contradictions—between fine art and popular craft, and between formal invention and social commitment—Calvo's art is purposely ambiguous as to its ultimate aesthetic determination.

PHYSICAL/METAPHYSICAL EPISTEMOLOGY: MIQUEL NAVARRO

Miquel Navarro's work is as deliberately equivocal as Calvo's. It too appears in some ways naive and ingenuous in relation to most present-day avant-garde art. Yet it is infused with the traditional avant-garde's social awareness translated into an autonomous cultural statement. In attempting to free his artistic language from the connotations of earlier idioms, Navarro hopes to alter the artist's relationship to society and ultimately transform society itself.

The artist, like Calvo, has chosen the ceramic medium. His profound understanding of its innate potential has allowed him to develop a highly personal style. Navarro's concentrated attention to his native environment was inescapable. As we have noted, for artists who cannot travel from Valencia, information from the outside has always been sparse, gleaned from books, periodicals and the broader cultural references of *Equipo Crónica*. Yet what might have been a handicap for some artists was turned by others like Navarro to an advantage, permitting them the freedom to invent an individual expression with neither a sense of frustration nor self-consciousness.

Clay, for Navarro, has broad cultural references. The medium is of course related to the craft tradition of Valencia, and the manual labor and skill necessary to work with it are ideologically important. But more significantly, for Navarro clay is the primordial medium of building, and indeed most human

production. The earliest material from which utensils, artifacts and architecture were shaped, it has been used from the time of prehistoric man to the Egyptians to the Arabs (whose presence is still felt in Valencia) to the present.

Furthermore, clay comes from riverbeds; in its natural state, it is earth and water; to be worked it requires air and fire. It is physical in the most real and the most philosophical sense. Yet, due to its innate malleability, once delivered into human hands, it may be fashioned into anything the human mind conceives, from the most abstract schema to the most concrete form or a synthesis of the two. Thus, its potential is truly metaphysical.

It is surely no accident that Navarro's ceramic pieces relate to both painting and architecture, the art of illusion and the art of construction. His themes —architectures, monuments, landscapes—are a painter's subject matter, and are, in fact, conceived pictorially: as an assemblage or dispersal of motifs within a closed, set frame. The allusion to painting is visible (although sometimes deflected by a more explicit reference to architecture, for example, in cat. no. 32) in the wall reliefs which comprise a large portion of his oeuvre. Yet his landscaped mesas or tables and the *Pyramid* obey the same laws and operate as paintings to be seen from above. Nonetheless, these pieces are extremely different from painting in their process (construction and placement), physical presence (volume and scale) and color range (mainly the natural colors of the materials); all of these properties modify the relationship of the work to the viewer as well as the viewer's ultimate experience of the work.

The emphasis in these pieces is graphic, decorative and compositional; the structures of the motifs are extremely elementary. The materials—sand, plaster, clay, stoneware—correspond naturally to the themes of building or landscape. But it is the artist's vision that dictates their assemblage, and the intermingling of widely diverse time frames, cultural codes and visual vocabularies which creates an extremely unsettling yet compelling effect.

Once again, displacement and re-creation are key concepts. We discover archeological remnants of De Chirico, Giacometti, Russian Constructivism, Egyptian pyramids, neo-classicist architecture, cacti and bulls' horns within one coherent yet elusive context; allusions to nature and culture, matter and mind, physics and metaphysics.

A broad repertory of human history and activity are reflected in these fragile, enigmatic forms: the spiritual and the mundane, the occult and the obvious, the ancient and the new, symbolism and formalism, sexuality and geometry, humor and seriousness, naiveté and complexity, the visionary and the real, the Arab and the Greek worlds, the pagan and Christian. These are not impossible contradictions but a synthesis of human experience. Beginning with a common material and a popular craft technique, Navarro has invented a formal vocabulary and an epistemology which remain open to multiple readings.

Although the artists in this exhibition were chosen for their intrinsic merits alone, upon closer appraisal they seem to represent a cross-section of recent trends in Spanish art. Extremely diverse, they share some general and fundamental characteristics: a reasoned decision to work within the conventions of their medium—be it painting, sculpture, ceramic, video—extending but not violating them; a commitment to a lived reality as well as to a broader cultural framework; a reference to nature as a constant presence as well as to artistic conventions; a Surrealist melange of introspection and scepticism; an interest in metaphor; an absence of explicit political content. One also sees the trace of regional influences: extreme politicization in Barcelona, strong social awareness in Valencia, for example. One can further argue that the light of Pérez Villalta is that of the south, whereas the palette of Gancedo is rooted in northern Castille. As has been suggested, these phenomena derive partly from the historically-determined circumstances of cultural and economic isolation. Limiting in one sense, these factors have allowed Spanish artists the freedom to be themselves.

Obviously, if these artists are to be of more than anthropological interest to the rest of the world, they must transcend their national boundaries, their local styles and preoccupations; they must transcend the limits imposed by a particular situation in order to communicate in universal terms. They must bridge a cultural gap. We think they do. Whether or not Spanish artists and critics agree, viewed from our perspective their message is critical, even subversive. Beyond the formal and stylistic qualities and differences of each artist, the work seen here connotes an opposition and/or indifference to current social values and internationally accepted aesthetic standards. Paradoxically, this rejection of today's established academies brings us back to the original meaning, stance and role of the "avant-garde."

CATALOGUE

The documentation for the catalogue was compiled by Blanca Sanchez Perciano, Madrid, with the help of Karen Cordero, Philip Verre and the artists themselves. The exhibitions lists and bibliographies were edited on the basis of available material in this country. The text of *Pamplona—Grazalema* (p. 69) was translated from the Spanish by Hardie St. Martin; the remaining artists' statements were translated by Lucy Flint, with the exception of Zush's which was written in English. The catalogue was edited by Carol Fuerstein and Margit Rowell.

In the checklist entries, measurement for height precedes width.

SERGI AGUILAR

Born in Barcelona, 1946
Studied at Escola Massana and Conservatori de les Arts del Llibre, Barcelona
Made abstract jewelry until 1971-72; since then has devoted himself entirely to sculpture
Lives in Barcelona

I would like to discuss the context that generates my sculptures rather than go into details about their forms and meanings. Material and immaterial forms exist in physical space. My observation of this space as well as of time and nature has led me to intuit that every mass occupies its own peculiar space. What we call "affinity" is a coincidence or approximation between things and actions which somehow correspond to similar places and positions. When this is produced, a harmony is established which helps us identify a term or object. This phenomenon cannot be explained, only felt.

An idea cannot exist by virtue of itself alone, or it would exist in a closed circuit. Ideas must exist in relation to other ideas or phenomena. This relation is external to the practice of art. If we opt for statements that are exclusively rational we run the risk of mechanizing and categorizing the work. This is the farthest thing from my mind. On the contrary, the motivations for my work are the observation of nature and the use of the imagination. When I use the terms "natural" and "nature" I do so not in the sense of stylization, but as a point of departure (origin) for the materialization of ideas that I would like to execute. Proportion, growth, balance are natural.

In observing nature, we see moments of great suggestiveness in time and space. The present is past and future almost simultaneously. Everything happens at a dizzying pace, although occasionally time is slowed or arrested by a situation or action.

We do not attach importance to time. Nonetheless, as we approach an event or the unfolding of an action, we perceive it and feel apprehension.

We are not aware of space, but when we are deprived of a single millimeter, we recognize its importance and feel its absence.

We have not been taught to look through time. To work with time requires an attitude with which we are not familiar. If we did, when faced with time's passage our vision would be broad enough to see the evolution of things and actions both partially and totally. The distance created by time makes identification possible.

I continually rethink my sculptures and often I glance backward to see what I could not see when I made them. To perceive the movement produced in actions already accomplished. This forward-backward movement produces a sum of practical experience, which generates the inspiration for the sculpture. My discourse attempts to approach the space-time-nature phenomenon with respect, paying maximum attention to all dimensions, a task that seems to me fundamental in sculpture.

Place, volume and material to be selected should be interrelated. The inappropriate use of any one of these elements provokes certain displacements, a lack of harmony, in which they may destroy one another.

SELECTED GROUP EXHIBITIONS

Instituto Británico, Barcelona, *New Forms*, June 5-10, 1972

Galería Juana de Aizpuru, Seville, *Cinco Artistas Catalanes*, October 1972

Galería Adrià, Barcelona, *MAN-73 Homenatge Joan Miró*, May 1973

Galería Trece, Basel, International Art Fair, *Art 4-73*, June 20-25, 1973

Collegi d'Aparelladors, Barcelona, *Mostra d'Art Realitat*, January 2-31, 1974

Galería Trece, Paris, *FIAC-75*, January 30-February 5, 1975

Galería J. Mas Zammit, Barcelona, *Escultores Mediterráneos*, January-February 1975

Galería Fondo de Arte, Madrid, *4 Escultores Catalanes*, May 1975

Galerías Adrià, Trece, Basel, International Art Fair, *Art 6-75*, June 18-23, 1975

Galería Ponce, Mexico City, *23 Artistas Catalanes de Hoy*, June 1975

Galería Eude, Barcelona, *Dibuixos i Obras Gráfica d'Escultors Contemporanis*, December 1975

Galería Arturo Ramon, Barcelona, *Escultura de Petit Format*, May-June 1976

Galería Trece, Basel, International Art Fair, *Art 7-76*, June 16-21, 1976

Fundació Joan Miró, Barcelona, *Museo Internacional Resistencia Salvador Allende*, July-August 1976

Galería Trece, Barcelona, *Dibuix: S. Aguilar, J. L. Pascual, A. Ney*, July-September 1976

Fundació Joan Miró, Barcelona, *Amnistia, Drets Humans i Art*, September 27-October 14, 1976

Galería René Métras, Barcelona, *El Collage a Catalunya*, February-March 1978

Galería Adrià, Barcelona, *S. Aguilar X. Francuesa, X. Grau, J. Hernàndez Pijuan, P. Puiggròs*, April 14-May 6, 1978. Catalogue

Staatliche Kunsthalle Berlin, *Katalanische Kunst des 20. Jahrhunderts*, June 25-August 23, 1978. Catalogue

Jahrhunderthalle Hoechst, Frankfurt am Main, *Katalanische Kunst seit 1970*, October 4-30, 1978. Catalogue

Galería Artema, Barcelona, *21 Escultors Contemporanis a Catalunya*, January 27-March 20, 1979. Catalogue

SELECTED ONE-MAN EXHIBITIONS

Instituto Británico, Barcelona, *Dibujos y Joyas*, January 14-27, 1969

Galerie Trudi Fath, Göppingen, Germany, *Schmuck*, September 4-October 1, 1969

Llibreria de la Rambla, Tarragona, *Objectes joia*, September 5-26, 1970

Galería Adria, Barcelona, *Escultura i Dibuix*, May 15-June 8, 1974. Catalogue

White Gallery, Lutry-Lausanne, *Dessins et Sculptures*, May 20-June 30, 1976

Galería Trece, Barcelona, *Escultures 1975-77*, April 14-May 14, 1977. Catalogue

Galería Trece, Basel, International Art Fair, *Art 9-78*, June 14-19, 1978. Catalogue

Galería Trece, Barcelona, *(Set Temps) "Transcurs" 18 Fotografies*, October 3, 1979

SELECTED BIBLIOGRAPHY

Newspapers and Periodicals

Alberto del Castillo, "Crónica de Barcelona," *Goya* (Madrid), no. 120, May 1974, pp. 385-386

Rafael Santos Torroella, "Sergi Aguilar," *El Noticiero Universal* (Barcelona), June 4, 1974

Daniel Giralt-Miracle, "Sergi Aguilar, *Destino* (Barcelona), no. 1914, June 8, 1974, p. 51

Enrique Da Cal, "tres exposiciones de escultura," *Athena* (Barcelona), no. 4, July 1974, p. 62

Rosa María Subirana, "Incidencia del contexto histórico, económico y social en la evolución de la escultura abstracta en España," *Estudios Pro Arte* (Barcelona), no. 4, October-November 1975, p. 26

Josep Iglesias del Marquet, "Sergi Aguilar," *Diario de Barcelona*, April 16, 1977

Francesc Miralles and Rosa Queralt, "En torno al grabado catalán de posguerra," *Estudios Pro Arte* (Barcelona), no. 10, April-June 1977, pp. 44-67

Alicia Suarez and Merce Vidal, "La mostra de Sergi Aguilar a la galería Trece," *Serra D'Or* (Barcelona), no. 212, May 15, 1977, p. 45

María Teresa Blanch, "El humano orden geométrico de Sergi Aguilar," *Batik* (Barcelona), no. 34, May 1977, pp. 30-31

Josep Iglesias del Marquet, "Crónica de Barcelona," *Goya* (Madrid), no. 138, May 1977, pp. 377-378

Arnau Puig, "Crónica de Exposiciones," *Artes Plásticas* (Barcelona), no. 18, June 1977, p. 37

Sergi Aguilar, "Encuesta a la joyería catalana," *Batik* (Barcelona), no. 36, September-October 1977, p. 22

Victoria Combalia, Alicia Suarez and Merce Vidal, "Tot sobre les setmanes catalanes a Berlin," *Artilugi* (Barcelona), no. 4, 1978, p. 4

María Teresa Blanch, "El arte español de 1980, abstracción y naturalismo," *Batik* (Barcelona), no. 50, 1979, pp. 5-7

Books

Willem Sandberg, ed., *"73-74" An Annual of New Art and Artists*, London, 1974, pp. 8-11

Ralph Turner, *Contemporary Jewelry: A Critical Assessment 1945-1975*, London, 1975, pp. 73-89, 142-143

Joan Ramon Triado, *Homenatge dels artistes catalans al Centre Excursionista de Catalunya*, Barcelona, 1976, pp. 56-57

José Marín-Medina, *La Escultura Española Contemporánea*, Madrid, 1978, pp. 344-345

Reinhold Reiling, *Goldschmiedekunst*, Pforzheim, Germany, 1978, pp. 52-56

1.
Horizontal—Three No. 2. 1976
(Horitzontal—tres No. 2)
Black Belgian marble, 11¾ x 37¾ x 5½″ (30 x 96 x 14 cm.)
Collection the artist

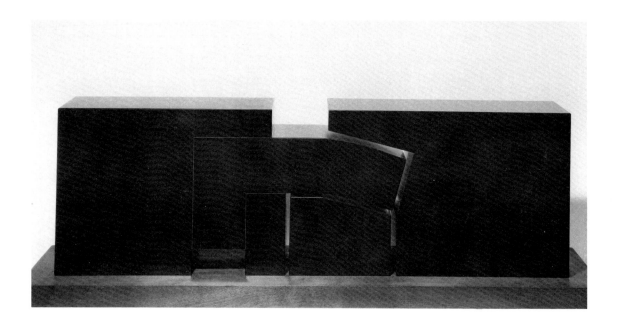

2.
Horizontal No. 6. 1977
(Horitzontal No. 6)
Black Belgian marble, 5½ x 35¾ x
2⅜" (14 x 91 x 6 cm.)
Collection J. Suñol, Barcelona

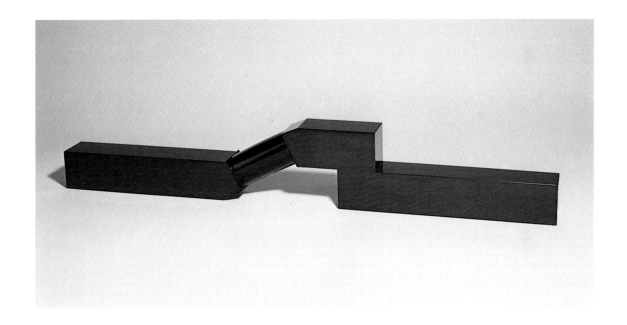

3.
Horizontal No. 8. 1977
(Horitzontal No. 8)
Black Belgian marble, 4¾ x 29½ x
2⅜″ (12 x 75 x 6 cm.)
Collection the artist

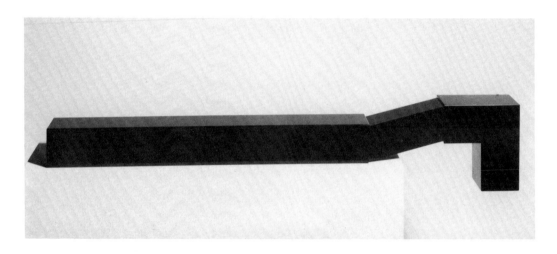

4.
Two-One. 1978
(Dues-Una)
Black Belgian marble, 6⅝ x 12 x
3⅛″ (17 x 31 x 8 cm.)
Collection the artist

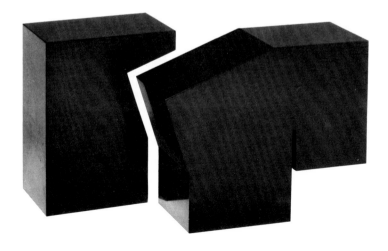

5.
Two-Three (P). 1978
(Dos-Tres [P])
Black Belgian marble, 4 x 23¼ x
15⅛″ (10 x 59 x 38.5 cm.)
Collection The Solomon R.
Guggenheim Museum, New York,
Anonymous Gift

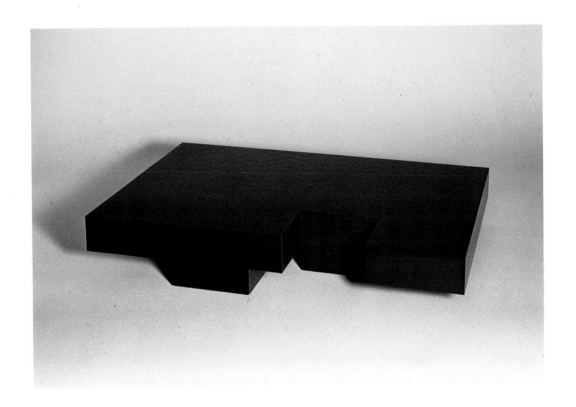

6.
Small Piece. 1978
(Petita Peça)
Black Belgian marble, 4 x 5⅝ x
7¼" (10 x 14.5 x 18.5 cm.)
Private Collection, Madrid

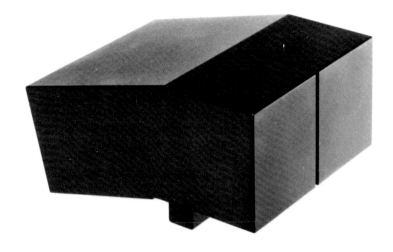

7.
Two-Three (2). 1978-79
(Dos-Tres [2])
Calatorao stone, with base 7⅞ x
26⅜ x 16⅞" (20 x 67 x 43 cm.)
Collection the artist

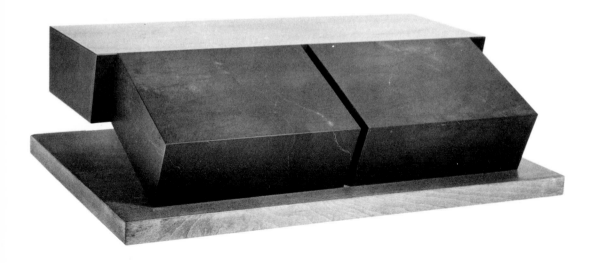

8.
Deep Notch No. 1. 1979
(Cran No. 1)
Black Belgian marble, 5 ⅞ x 23 ⅝ x
38 ⅜″ (15 x 60 x 97.5 cm.)
Lent by Galería Vandrés, Madrid

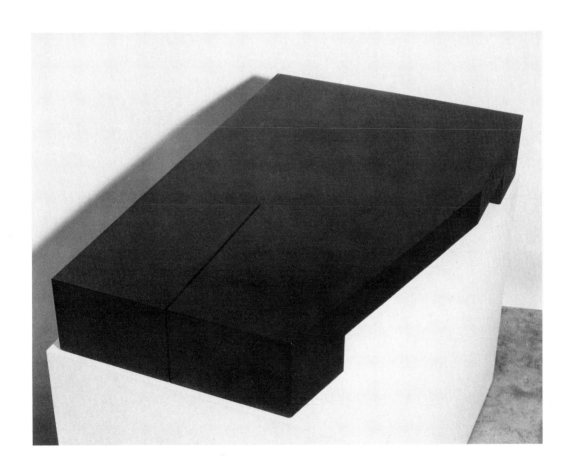

9.
Two-Three (V). 1979
(Dos-Tres [V])
Calatorao stone, 16½ x 22 x 6⅛"
(42 x 56 x 15.5 cm.)
Collection the artist

10.
Positions No. 2. 1979
(Posicións No. 2)
Black Belgian marble, 13 x 14¾ x
12¼" (33 x 37.5 x 31 cm.)
Collection the artist

11.
Positions No. 3. 1979
(Posicións No. 3)
Black Belgian marble, 13 x 11¾ x
11¾" (33 x 30 x 30 cm.)
Collection J. Suñol, Barcelona

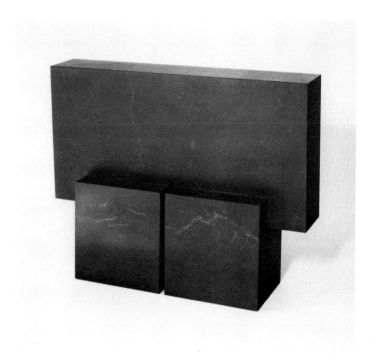

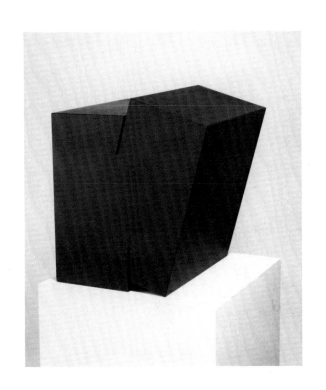 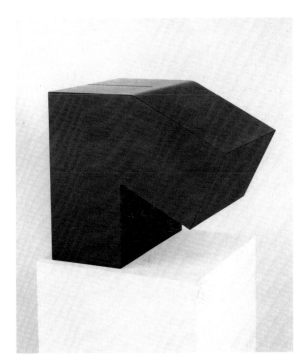

CARMEN CALVO

Born in Valencia, 1950
Studied at Escuela de Artes y
Oficios, Valencia, 1962-65 (degree
in graphic arts: advertising); Escuela
Superior de Bellas Artes de San
Carlos, Valencia, 1969-72
Lives in Valencia

As Tàpies so rightly says, we, in general, keep silent, because from the outset we resign ourselves to the impossibility of explaining our work in a few words; one would still have to discover many of the things we have incubated throughout months and years. Or as Henri Matisse said, the best explanation of his style a painter can offer will be found in his canvases themselves. By this I mean to say that it is difficult to explain one's work.

The task of experimentation the painter sets himself, the constant battle with his materials, the manipulation of the abandoned materials he attempts to recover—all this forms part of my creative process. I paint with the ordinary objects of the painter (or those close to my cultural milieu): pencils, sandpaper, colored chalk, canvases, tubes of oil paint, rags. . . . Or clay, which is linked with my past work in ceramics; white or red clay with which I produce forms and order and number them.

My development is based on the idea of archeology, an idea that fascinates me: the concept of repetition and recovery of the object.

In 1971 I traveled to Paris and stayed there for two months to study the work of Paul Cézanne and Henri Matisse. I became acquainted with the Egyptian art in the Louvre. I was interested in archeology and all that surrounded it — most of all, the processes of discovering, reconstructing and compiling archeological remains of Near Eastern cultures. These elements and materials would serve as a source of inspiration for my later works.

I am aware that definitions are always dangerous; they tend to reduce a concept to a few words, which may become unclear and simplistic. However, I believe that it is necessary to provide these clues to the spectator.

Three aspects in painting interest me: form, color and object. I began with painting in oil and acrylic, and with the subject of landscape treated in an Impressionist manner. I am still interested in landscape; I use it to examine the facture of Impressionism, but do not paint in an Impressionist style. I am still concerned with traditional premises: the primacy of the idea of *painting* and the *objects* of the painter.

I believe that my work has some European antecedents, but I have concerned myself with the sources of our native tradition: clay and all the materials that are in some way culturally related to the Valencian region.

GROUP EXHIBITIONS

Círculo Universitario de Valencia, *Nuestro Yo*, January 15-31, 1969

Sala Mateu, Valencia, *Paisajes*, May 1-30, 1969

Círculo de Bellas Artes de Valencia, *Bodegones y Paisajes*, February 1970

Caja de Ahorros de Alicante, Valencia, *Paisajes*, March 1970

Galería Barandarian, Bilboa, *Personajes Iguales*, April 1971

Salón Nacional, Tortosa, *Paisajes en Barro*, July-August 1973

Sala Atenas, Zaragoza, *Paisaje*, August 1974

Galerías Punto, Temps, Val i 30, Valencia, *Els Altres 75 Anys de Pintura Valenciana*, April-July, 1976. Traveled in Spain

Galería Sen, Madrid, *Seis Artistas Valencianos*, October 28-November 28, 1977. Catalogue

Museo Arqueológico, Palacio de la Diputación Provincial de Palencia, Palencia, *Exposición Internacional de Artes Plásticas: Homenaje a Jorge Manrique*, September 1-9, 1979

ONE–WOMAN EXHIBITIONS

Galería Temps, Valencia [with Miquel Navarro], November 16-December 16, 1976. Catalogue

Galería Buades, Madrid, May 20, 1977. Catalogue

Galería Yerba, Murcia, February 16-March 16, 1979

Galería Vandrés, Madrid, *Pinturas*, April 27-May 27, 1979. Catalogue

SELECTED BIBLIOGRAPHY

Newspapers and Periodicals

Luis Mañez, "Carmen Calvo y Miquel Navarro," *Dos y Dos* (Valencia), no. 27/28, November 28, 1976

R. Ventura Melia, "Avantguarda i arqueología," *AVUI* (Barcelona), December 12, 1976

Eduardo Chávarri Andujar, "Dos vertientes de la Pintura Valenciana: El Maestro Furio y el Tandem Carmen Calvo — Miquel Navarro," *Las Provincias* (Valencia), December 21, 1976, p. 18

Juan M. Bonet, "Corto viaje a Valencia y su pintura," *El País* (Madrid), December 23, 1976

José Garneria, "Galería Temps," *Arteguia* (Madrid), no. 24, December 1976, p. 25

José Garneria, "Carmen Calvo y Miquel Navarro," *Artes Plásticas* (Barcelona), no. 14, December 1976, p. 48

Fernando Huici, "Carmen Calvo," *El País* (Madrid), June 2, 1977, p. 29

Fernando Huici, "Seis artistas valencianos," *El País* (Madrid), November 3, 1977, p. 22

Victoria Combalia, "Una nueva generación valenciana. Arqueología y autoreflexión de una práctica," *Batik* (Barcelona), no. 45, November 1978, pp. 18-19

E. Arlandis, "Aproximación a la obra de Carmen Calvo," *Cartelera Turia* (Valencia), no. 794, April 23, 1979

Fernando Huici, "Carmen Calvo, lo femenino y el arte," *Batik* (Barcelona), no. 49, April-May 1979, pp. 49-50

Francisco Rivas, "Dos Pintoras Valencianas," *El País* (Madrid), May 3, 1979, p. 34

Miguel Logroño, "Carmen Calvo, entre la arqueología y la pintura," *Diario 16* (Madrid), May 16, 1979, p. 24

Manuel García i García, "Notas sobre la pintura valenciana de los setenta," *Batik* (Barcelona), no. 50, July-August 1979, pp. 43-45

12.
Anthology. 1975
(Recopilación)
Red clay on canvas mounted on
wood panel, 59 x 74¾" (150 x 190
cm.)
Collection Enrique del Pozo
Parrado, Madrid

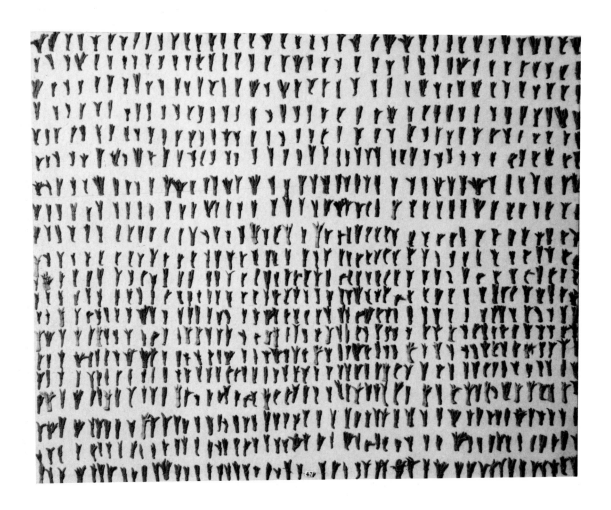

13.
Anthology (Landscape). 1977
(Recopilación [Paisaje])
Painted white clay on canvas
mounted on wood panel, 59 x 74¾″
(150 x 190 cm.)
Collection The Solomon R.
Guggenheim Museum, New York,
Anonymous Gift

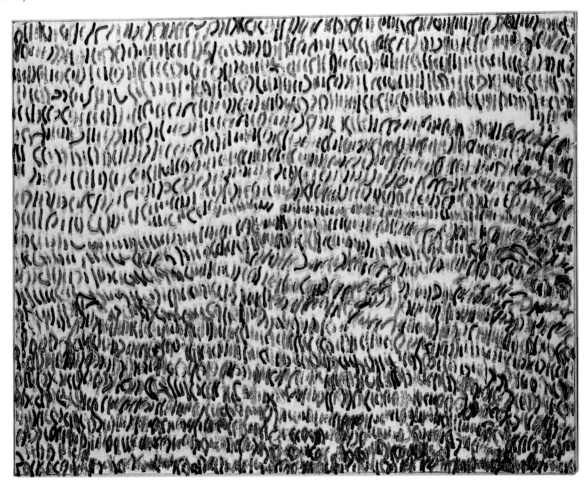

14.
Anthology Series. 1977
(Serie Recopilación)
Painted ocher clay on canvas
mounted on wood panel, 59 x 74¾″
(150 x 190 cm.)
Lent by Galería Vandrés, Madrid

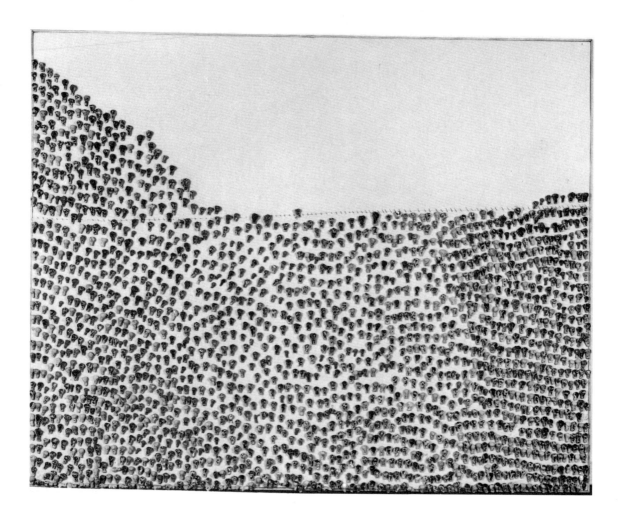

15.
Reconstruction Landscape Series.
1977
(Serie Reconstrucción Paisaje)
Clay on canvas mounted on wood
panel, 33½ x 46½″ (85 x 118 cm.)
Collection J. Suñol, Barcelona

16.
Anthology of Forms. 1979
(Recopilación de formas)
White clay on canvas, 51⅛ x 63¾"
(130 x 162 cm.)
Private Collection, San Francisco

17.
Landscape Series. 1979
(Serie Paisajes)
Red clay on canvas, 33½ x 33½″
(85 x 85 cm.)
Collection the artist

18.
Colored-Chalk Landscape. 1979
(Paisaje Tizas de Colores)
Colored chalks on canvas mounted
on wood panel, 47¼ x 47¼" (120 x
120 cm.)
Collection J. Suñol, Barcelona

19.
Colored-Chalk Landscape. 1979
(Paisaje Tizas de Colores)
Colored chalks on canvas, 47¼ x
47¼″ (120 x 120 cm.)
Collection Lambert, Brussels

TERESA GANCEDO

Born in León (Castille), 1937
Moved to Madrid, 1939; to
Barcelona, 1960
Studied at Escola Massana,
Barcelona, 1967-69; Escuela Superior
de Bellas Artes de San Jorge,
Barcelona, 1969-73
Lives in Barcelona

Reality is the foundation of my plastic language. This reality is not objective, but subjective and almost always transformed by the honest trickery that recollection infuses into everything that happens to us.

I would like my works to be seen as fleeting, equivocal representations of the world and of life. They are not meant to be critical or literal, but to present a reality interwoven with memories of years, of names, of mystery, of sorrow, of joys. Memory is also truth and life, another form of blood, in the words of a Spanish poet.

In my current work there are four elements of central interest to me: object, space, time and color.

The object, which I usually make myself, appears in various guises on the canvas. Sometimes it is a faithful drawing of the object and sometimes it is the object itself. I am attempting to treat and manipulate reality in an ambiguous way, making it difficult to establish the boundaries between the represented object and the real object; this creates a profoundly tactile feeling.

Space is created, in the first place, as a cradle for all other elements; my intention is that this space and these elements communicate their identity in a continual dialogue, in a bidimensional-tridimensional relationship.

Color is treated in the most sober manner possible. Only in the object do I attempt absolute fidelity of color. Throughout the surface of the painting an important role is played by the gray tones, with their gradations, transparencies, etc.

Into these elements—objects, space, color—I incorporate time. This is shaped by the deterioration of the subject. The images used are always petrified, volumetric, static. Mobility is represented, nevertheless: it is the mobility created by the sequence of images in a space which is more or less defined.

SELECTED GROUP EXHIBITIONS

Barcelona, *Premio internacional de dibujo Inglada Guillot*, November 1970

Barcelona, *X Salón femenino del arte actual*, October 1971

Museo de Arte Contemporáneo, Madrid, *Salón internacional de pintura feminina*, June 1973

Barcelona, *20 Premio de Dibujo San Jordi*, April 1974

Fundaçiõ Gulbenkian, Lisbon, *XIII Premio internacional de desenho Joan Miró*, November 1974. Catalogue

Centre Culturel et Social Municipal, Limoges, *Evidence / Apparence*, May 1976

Galería Ponce, Mexico City, *Los realismos en España*, 1976

Centre Culturel et Social Municipal, Limoges, *Paradis perdu: Recherche d'identité*, April-May 1977. Catalogue

Caldas da Rainha, Portugal, *IV Encontros Internacionais de Arte*, August 1-12, 1977

León, Spain, *IV Bienal del Realismo*, December 14, 1977-January 12, 1978

Galería Victor Bailó, Zaragoza, *Ocho pintores catalanas*, April 10-30, 1978. Catalogue

Paris, *29e Salon de la jeune peinture*, May 16-June 15, 1978. Catalogue

Les Gémeaux—Centre d'Action Culturelle, Paris (Sceaux), *Fièvre Froide*, May 1978. Catalogue

Palma de Mallorca, *Homenaje Joan Miró*, July-August 1978

SELECTED ONE—WOMAN EXHIBITIONS

Sala Provincial, León, Spain, December 1972

Sala de la Cultura de la Caja de Ahorros Provincial, Pamplona, June-July 1973

Sala Ausias March, Barcelona, November 1974

Galería Ovidio, Madrid, December 15, 1975-January 8, 1976

Galería Val i 30, Valencia, June 2-30, 1976. Catalogue

Galería Ciento, Barcelona, *Teresa Gancedo—Obra sobre papel*, February 16-March 12, 1977. Catalogue

Galería Vandrés, Madrid, *Teresa Gancedo—Oleos y dibujos*, October 4-November 9, 1977

Sala Pelaires, Palma de Mallorca, *Teresa Gancedo—Obra reciente*, May 24-June 15, 1978

Sociedade Nacional de Belas Artes, Lisbon, July 14-August 10, 1978. Catalogue

Galería Pepe Rebollo, Zaragoza, *Teresa Gancedo—Pinturas*, February 5-24, 1979. Catalogue

Galería Cop-D'ull, Lérida, Spain, *Pintura y dibujo*, March 9-30, 1979

Museo de Arte Contemporáneo, Seville, *Teresa Gancedo: Discurso sobre la realidad (Obra realizada entre 1976-1979)*, May 15-June 9, 1979. Catalogue

SELECTED BIBLIOGRAPHY

Newspapers and Periodicals

Daniel Giralt-Miracle, "Teresa Gancedo," *AVUI* (Barcelona), February 2, 1977

Teresa Blanch, "La imaginada realidad de Teresa Gancedo," *Batik* (Barcelona), no. 31, February 1977, pp. 25-26

Ana Moix, "Teresa Gancedo: La objetividad, lo real imaginario y lo simbólico," *Vindicación feminista* (Barcelona), no. 10, April 1, 1977

M. A. García Viñolas, "Teresa Gancedo," *Pueblo* (Madrid), October 12, 1977

María Teresa Casanelles, "Teresa Gancedo y sus ciclos vitales," *Hoja del Lunes* (Madrid), October 17, 1977

Enrique Azcoaga, "Teresa Gancedo," *Blanco y Negro* (Madrid), no. 3417, October 26, 1977

Raul Chávarri, "Teresa Gancedo," *TG* (Madrid), December 1977, pp. 54-55

Felix Guisasola, "Teresa Gancedo: lo no esencial," *Guadalimar* (Madrid), December 1977, pp. 91-92

Manuel Barbosa, "Teresa Gancedo artista espanhola," *Pagina Um* (Lisbon), February 10, 1978

Jaime Nicolau, "Iconografía de la vida y la muerte," *Diario de Mallorca*, June 2, 1978

Mariano Planells, "Teresa Gancedo: Visión y participación," *Batik* (Barcelona), no. 42/43, May-June 1978, p. 65

Mario de Oliveita, "Teresa Gancedo (pintora espanhola) e o realismo ecológico," *O País* (Lisbon), August 4, 1978

"Exposiciones en 'Pepe Rebollo,' 'Gambrinus' y Hogar Navarro," *Amanecer* (Zaragoza), February 10, 1979, p. 5

A.A., "Galería Pepe Rebollo: Teresa Gancedo," *Heraldo de Aragón* (Zaragoza), February 11, 1979

Books

Raul Chávarri, *Artistas contemporáneas en España*, Madrid, 1976

Gillo Dorfles, *Ultimas tendencias del arte de hoy*, Barcelona, 1976

Gloria Moure, "The Specificity and Dead-end of Spanish Artistic Creation," *Art actuel: Skira annuel*, Geneva, 1979, pp. 142-144

20.

The Dried Branch. 1977
(El tronco seco)
Oil and objects on canvas mounted
on wood panel, 24⅝ x 18⅛″
(62.5 x 46 cm.)
Collection Font Diaz, Barcelona

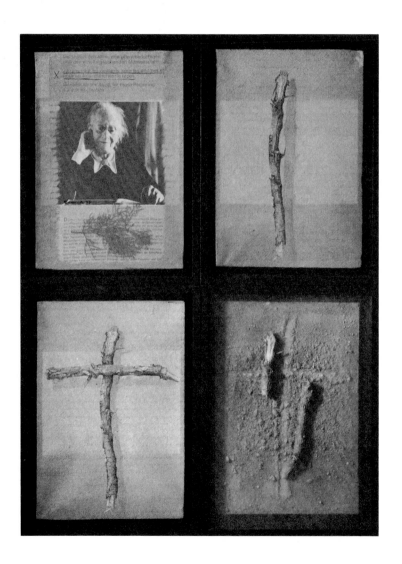

21.

The Loved Ones. 1977
(Los seres queridos)
Oil and objects on canvas mounted
on wood panel, 24⅝ x 18⅛"
(62.5 x 46 cm.)
Collection J. Carrillo de Albornoz,
Granada

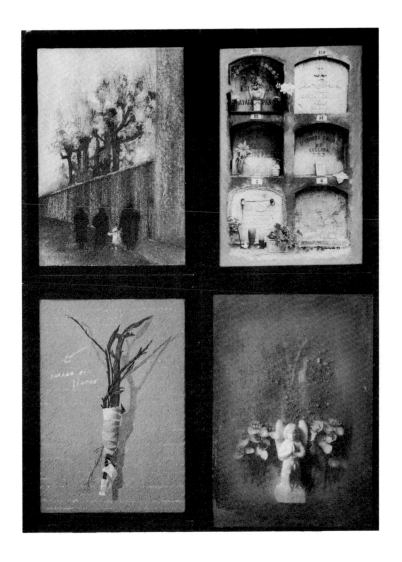

22.

Discourse on Reality. 1978
(Discurso sobre la realidad)
Mixed media and objects on canvas,
44⅛ x 61⅜″ (112 x 156 cm.)
Collection J. Suñol, Barcelona

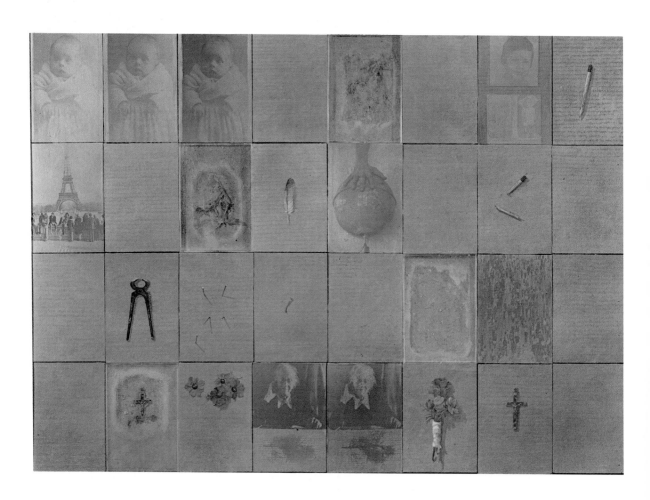

23.
The Wounded Flower. 1979
(La Flor herida)
Oil and acrylic on canvas, 74¾ x
72⅜″ (190 x 184 cm.)
Collection The Solomon R.
Guggenheim Museum, New York,
Anonymous Gift

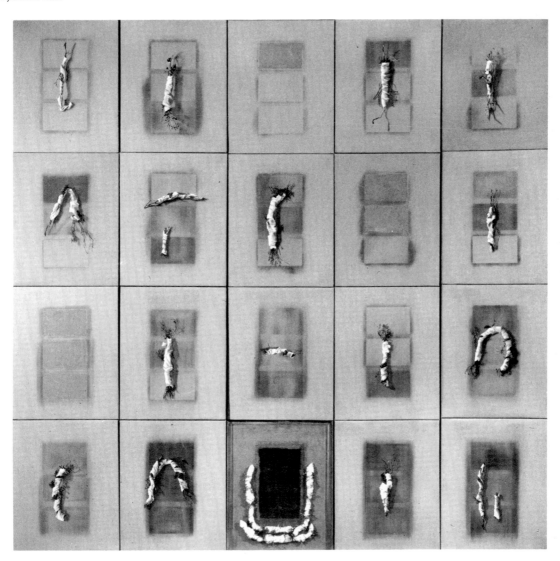

24a.
The Wreath. 1979
(La Corona)
Gouache on board, 24⅜ x 24⅜″
(62 x 62 cm.)
Collection the artist

24b.
The Wreath. 1979
(La Corona)
Oil on canvas, 51⅛ x 76¾″
(130 x 195 cm.)
Collection the artist

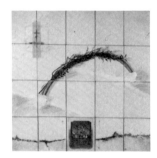

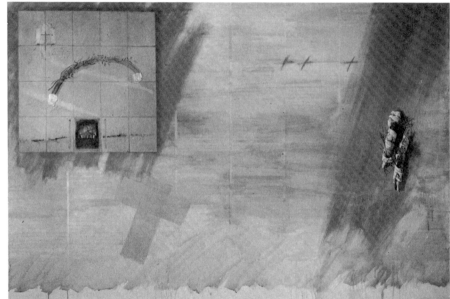

25.
Relics I. 1979
(Reliquias I)
Acrylic and oil on canvas, 51⅛ x
42½″ (130 x 108 cm.)
Collection the artist

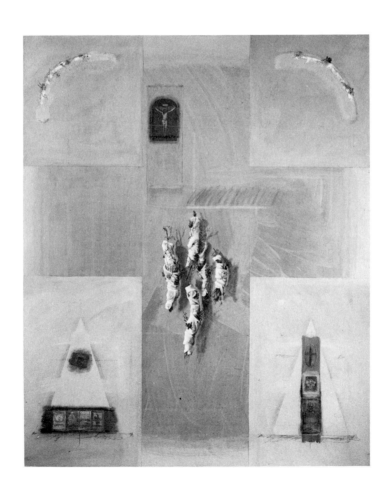

26.
Relics II. 1979
(Reliquias II)
Acrylic and oil on canvas, 51⅛ x
42½″ (130 x 108 cm.)
Collection the artist

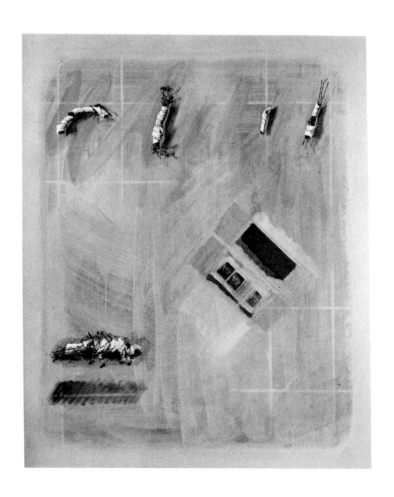

27.
Another Time, Another Space. 1979
(Otro tiempo, otro espacio)
Acrylic and oil on canvas, 51⅛ x
63¾″ (130 x 162 cm.)
Collection the artist

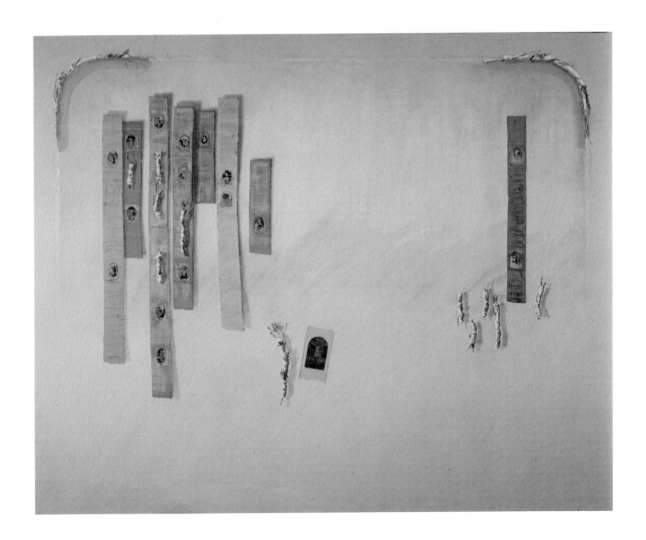

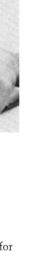

Born in Barcelona, 1942
Studied at Universidad de Barce-
lona, 1959-62; Escuela Técnica
Superior Ingenieros Industriales,
Barcelona, 1963-67
Moved to United States, 1972
Since 1977 has worked at Center for
Advanced Visual Studies, Massa-
chusetts Institute of Technology,
Cambridge
Lives in Cambridge and New York

Born in Ceuta (Spain), 1949
Studied at New York University,
1973-76 (M.A. in Anthropology);
from 1977 The City University of
New York (currently Doctoral
Candidate in Anthropology)
Lives in New York

PAMPLONA-GRAZALEMA:
THE RITUAL OF THE BULL IN SPAIN

Pamplona-Grazalema is the result of a series of visual media and anthropological works done from 1975 to 1979. The social sciences and the visual arts are combined in an interdisciplinary effort to study the symbolism of the bull in Spain. Two feasts of the bull are considered: one celebrated in Pamplona in honor of San Fermín, the other in Grazalema, to commemorate the day of Our Lady of Mount Carmel.

The Bull, the Church and Spain

As a nation moves through history, many cultural elements that are important at one time gradually lose their significance and disappear. Some symbols die along the way, new ones sprout up while other remain permanently. Thus, in Spain many symbolically expressive rituals and fiestas have lasted for centuries.

The fiesta of the bulls is the most important of these. The strength, courage and sexual power attributed to the bull have won it a central place in Mediterranean mythology. Spain is the only country that has preserved vestiges of these rites and games in varied forms. And the imprint of the bull has been reflected in her literature and art from ancient times to the present day.

In a country where the Church has always been so influential, the existence of fiestas involving the bull side by side with Christian ritual is an enormous contradiction. The Church which could not destroy the deeply ingrained fiestas was forced to Christianize them and incorporate them into the Christian calendar. This way, the local spirit of the people would not violate its authority. At the same time, the people could hold on to their identity but within the structure of the Church. Within the framework of the present-day bullfight traces of sacrifices, holocausts and ancient rites linked to the cult of the bull are preserved like the ruins of pagan temples under Christian basilicas.

The Virgin's Bull

In the small hill town of Grazalema a fiesta of the bull has been celebrated for centuries: the fiesta is one of the few in Spain that still preserves its original purity. It commemorates the day of Our Lady of Mount Carmel, whose image is carried from the church to the accompaniment of hymns and music. Men and women hail her as if she were the town beauty, as beautiful as the Greek goddess worshipped by the ancient Grazalemans centuries ago. But in addition to beauty incarnate Venus is now also Virgin and Mother. The vitality of the people's religious feelings is most powerfully expressed in the personal relationship with the Virgin, nurtured in these processions and public acts, rather than in a dogmatic Church.

On the day following the procession, a bull with a long rope knotted to his horns is run through the streets. From balconies and windows women and children look on, while men get close to the animal and run him, trying furiously to make him charge. The animal fights for his life, charging wildly; people scramble out of his way. Metaphorically, his power is taken over that day by every man in town. As man becomes animal, the beast becomes human. With strength and courage gone, the bull becomes a tame animal; with this symbolic death the fiesta ends.

In contrast to the religious and moral solidarity that prevails during the procession, chaos reigns on the day the bull is run. There are no rules or laws that day; the freedom and the will of the people hold sway. The feast of the Virgin celebrates femininity, the bull's celebrates masculinity. She stands for motherly love, unity, purity and is part of a world of spiritual dimension. But the bull symbolizes sexual vigor and bravery and he belongs to the material life, the physical world of man.

The Bulls of San Fermín

Pamplona's bull festival is one of the most widely known in Spain. The San Fermín festivities last for a week, and have been celebrated almost without interruption since 1591.

Pamplona has a long bullfighting tradition. Hundreds of years before the modern corrida came into being, bulls were run on a rope lead or with their horns covered with tow and pitch and set on fire to celebrate special occasions. Saints' feasts, the building of churches and even canonizations were commemorated with bulls. In Pamplona there have been churchmen who raised brave bulls or even fought them, a bishop who was president of a corrida, and priests who leapt into the ring. Bulls have been run not only in the plazas or through the streets but in the churches as well. Priests have run bulls and, on one occasion at least, Capuchin nuns ran a wild cow inside their convent's walls.

The most fascinating part of Pamplona's fiesta is the running of the bulls through the streets each morning. The city holds its breath. The running lasts only a few minutes but while it does, the bulls plow the streets, sowing panic and inspiring valor. In the last fifty years, ten people were killed and some 3,600 wounded. Tourists from all over the world feel the special excitement generated by the fiesta, unique in the soul of Spain, that draws everyone together into a single body. The music, the shared *bota* of wine and the general rejoicing intermingle in a dramatic dance with passion, danger and the specter of death. In the last few years graffiti and political propaganda have covered the walls of the houses and overshadowed or hidden the bullfight posters and programs. In a budding political society the feast of San Fermín has also created room for protest.

Fiestas dedicated to the bull have endured in Spain because over the years they infiltrated her culture in the areas of language, religion, economics, politics and social organization, leaving visible traces in the ideological structure. These socio-cultural forms embedded in the local culture are precisely what keeps the fiesta alive. The central purpose, then, of *Pamplona-Grazalema* has not been to study the visual medium or the fiesta itself, but to relate it to society and see how it has worked into the social units and became an integral part of the world view and values of the people.

NOTES PARALLEL TO THE PROJECT

The project *Pamplona-Grazalema* is an installation of videotape, film and slides, together with a book of texts and images. It is an attempt to approach greater objectivity by combining distinct methodologies which give as complete a vision as possible of the symbolism of the bull and what it represents in Spain.

Over the past five years the visual conception and point of view of this project has evolved through personal selection and reduction into two complementary presentations which have taken the following form:

Videotape: a fast medium. Images and sound symbolic and suggestive of information as well as audio-visual references.

Publication: a slow medium. Texts and graphic images which present the background information with greater density.

Installation:

Two fifteen-minute tapes, one devoted to Pamplona, the other to Grazalema, are run simultaneously on separate monitors. The juxtaposed material contrasts the following elements:

bull and people
silence and sound
color (red for Pamplona; green for Grazalema) and black and white
abstract and realistic images

The result is a visual, referential and symbolic body of work which is complemented by the publication.

Publication:

Texts and images which place the project in a socio-anthropological framework that includes references to the historical, economic and political context; transcriptions of interviews and a conclusion in which the authors present a critical assessment of the project and review the premises and outcome of an interdisciplinary collaboration.

Technical data:

Preparation time: June 1975-February 1980. Field work and filming in Pamplona and Grazalema in July 1975, 1976, 1977, 1978 and 1979.

Accumulated visual material: 4 hours of film; 22 hours of videotape; 2,000 slides.

Collaboration (field work and post-production help): John Barnett, Daniela Tilkin, Manel Perez, Katya Furse, Lala Goma, Lopez Tavanazzi, Eugeni Bonet, Mark Abate.

Post-production work: Film/Video Department, Massachusetts Institute of Technology, Cambridge; Massachusetts School of Arts, Boston; Educational Video Resources, Massachusetts Institute of Technology.

Acknowledgements: Comité Conjunto Hispano Norteamericano, Madrid; Center for Advanced Visual Studies, Massachusetts Institute of Technology; Galería Vandrés, Madrid; Spanish Tourist Office, New York, Promoción Artes Plasticas e Investigación Nuevas Formas Expresivas; Ministerio de Cultura.

MUNTADAS

SELECTED GROUP EXHIBITIONS

Sala Lleonart, Barcelona, *Machines*, April 1963. Catalogue

Barcelona, *Premi Joan Miró*, 1964, 1967. Catalogues

Barcelona, *Salo de Maig*, 1965, 1966, 1967. Catalogues

Buenos Aires, *Arte de sistemas II.* 1972

Pamplona, *Encuentros*, 1972. Catalogue

Banyoles, Spain, *Informacio d'Art Concepte*, February 1973. Catalogue

Colegio de Arquitectos, Valencia, *Cuatro Elementos*, May 1973. Traveled to Galería Juana de Aizpuru, Seville, June. Catalogue

Museu de Art Contemporánea da Universidade de São Paulo, *Prospectiva 74*, August 1974. Catalogue

Musée des Arts Décoratifs, Lausanne, *Impact Video Art*, October 1974. Catalogue

Musée d'Art Moderne de la Ville de Paris, *Art/Video Confrontation 74*, November-December 1974. Catalogue

Palais des Beaux-Arts, Brussels, *Artists Videotapes*, January 1975. Catalogue

Museo de Arte Contemporáneo, Caracas, *Arte de Video*, April 1975. Catalogue

Galeria Wspolzesna, Warsaw, *Sztuka Video I Socjologiczna*, June 1975. Catalogue

IX Biennale de Paris, October 1975. Catalogue

Venice, *Biennale Internazionale d'Arte, Spagna: Vanguarda Artistica, Realtà Sociale*, June-October 1976. Catalogue

Kassel, *Documenta 6*, June-October 1977. Catalogue

Graz, Austria, *Mediart*, October 1978. Catalogue

Alberta College of Art Gallery, Calgary, *Videonet*, March 1979. Catalogue

The Museum of Modern Art, New York, *Video Viewpoints 1979, Subjectivity/Objectivity: Private/Public Information*, April 1979

Museum Folkwang Essen, *Videowochen Essen '79*, November-December 1979. Catalogue

SELECTED ONE-MAN EXHIBITIONS

Galería Vandrés, Madrid, October 1971. Catalogue

Galería René Métras, Madrid, January 1973

Galería Vandrés, Madrid, December 12, 1974-January 3, 1975. Catalogue

Stefanotti Galery, The Video Distribution Inc., New York, April 2-3, 1975

Internationaal Cultureel Centrum, Antwerp, November 13-December 12, 1976. Catalogue

Anthology Film Archives, New York, February 25-26, 1977

Everson Museum of Art, Syracuse, *Bars*, April 15-May 15, 1977

The Museum of Modern Art, New York, *Projects: Video XVIII*, May 4-9, 1978

Vancouver Art Gallery, March 16-April 16, 1979. Catalogue

SELECTED SPECIAL PROJECTS

Automation House, New York, *Confrontations*, April 1974. Installation

Galería Cadaques, *Cadaques Canal Local*, July 1974. Video

C.A.Y.C., Buenos Aires, *The Last Ten Minutes (Part I)*, March 14-20, 1976. Video

Venice, *Biennale Internazionale d'Arte: N./S./E./W.*, June-October 1976. Installation

Galería Ciento, Barcelona, *Barcelona Distrito Uno*, October 1976. Video

Kassel, *Documenta 6: The Last Ten Minutes (Part II)*, June-October 1977. Installation

P.S. 1, New York, *Yesterday, Today, Tomorrow*, April-May 1978. Installation

Hayden Gallery, Massachusetts Institute of Technology, Cambridge, *On Subjectivity*, December 21-23, 26-29, 1978. Book and video

Boston Film/Video Foundation, *Between the Lines*, February 1979. Video

Espai B5-125, Universitat Autonoma, Barcelona, *Dos Colors*, November 1979. Installation

SELECTED BIBLIOGRAPHY

On the artist

Newspapers and Periodicals

Alexandre Cirici, "Antonio Muntadas i l'art táctil," *Serra D'Or* (Barcelona), September 1971, pp. 63-65

María Lluìsa Borràs, "Panorama de Novísimos Catalanes," *Destino* (Barcelona), no. 1791, 1971

"Muntadas: La Actividad Conceptual," *Tropos* (Madrid), no. 7/8, May 1973, pp. 99-104

José Maria Marti Font, "Cadaques Canal Local," *Diario de Barcelona*, August 1974

Juan M. Bonet, "Los Medios y su Uso Alternativo a propósito de Muntadas," *Solución* (Madrid), February 1975

Guy Dumur, "Contre l'art marchandise," *Le Nouvel Observateur*, June 1975

Alexandre Cirici, "Muntadas: Cadaques Canal Local," *Plus Moins Cero* (Genval, Belgium), no. 10, September 1975

Bernard Teyssèdre, "Le Bal des Copieurs," *Le Nouvel Observateur*, September 1975

Victoria Combalia, "Les avant-gardes en Espagne," *Art Press* (Paris), no. 22, January-February 1976, pp. 26-27

Francisco Rivas, "Muntadas hacia una estrategia de los medios," *El País* (Madrid), October 1976

José Maria Marti Font, "Alternativa a la T.V.," *Viejo Topo* (Barcelona), November 1976

Dany Bloch, "L'Art comme provocation," *Info Artitudes* (Paris), no. 14, January 1977

"Last Ten Minutes," *Flash Art* (Milan), no. 76/77, July/August 1977, p. 41

Wulf Herzogenrath, "Der latente Zundstoff: Video könnte das Intendanten—Fernsehen ablösen," *Kunst Forum*, no. 3, August 1977

Santiago Amon, "El Ultimo Experimento de Antonio Muntadas," *El País* (Madrid), September 1977

Gloria Moure, "Interview: Vanguardias Artísticas y Realidad Semiológica," *Destino* (Barcelona), no. 2112, March 1978

Victor Ancona, "Antonio Muntadas: from Barcelona to Boston," *Videography*, no. 5, May 1978, pp. 55-58

Richard Simmons, "Video Art: Spain and Syracuse, N.Y.," *Televisions*, no. 4, 1978

"About Invisible Mechanisms," *Visions* (Boston), no. 2, February 1979

Anne Bray and Ferol Breyman, "Muntadas: Personal/Public Conversation," *Video Guide* (Vancouver), June 1979

Jo-Anne Birnie Danzker, "Reading 'Between the Lines,'" *Centerfold* (Toronto), no. 5, July 1979

María Teresa Blanch, "Muntadas i l'alternativa dels mitjans," *AVUI* (Barcelona), October 21, 1979, p. 2

Alexandre Cirici, "L'environament invisible d'Antoni Muntadas," *Serra D'Or* (Barcelona), October 1979

Books

Simon Marchant, *Del arte objetual al arte conceptual*, Madrid, 1972

Raul Chávarri, *La Pintura Española Actual*, Madrid, 1973

Victoria Combalia, *La Poética de lo Neutro*, Barcelona, 1975

William Dyckes, ed., *Contemporary Spanish Art*, New York, 1975, p. 153

Guy Dorfles, *Ultimas tendencias del arte de hoy*, Barcelona, 1976

Beryl Korot and Dora Schneider, eds., *Video Art*, New York, 1976

Achille Bonito Oliva, *Europe-America: The Different Avant-Gardes*, Rome, 1976

Horst Wackerbarth, *Kunst und Medien*, Kassel, 1977

Art Artist the Media, Graz, 1978

Kane, ed., *Video 80*, Rome, 1979

Gloria Moure, "The Specificity and Dead-end of Spanish Artistic Creation," *Art actuel: Skira annuel*, Geneva, 1979, pp. 142-144

By the artist
Publications

Actividades I, Galería Vandrés, Madrid, 1972

Actividades II-III, Galería Vandrés, Madrid, 1976

Emisio — Recepio (Postales), Art Enlla, 1976

On Subjectivity, Visible Language Workshop and Center for Advanced Visual Studies, Cambridge, Massachusetts, 1978

September 11, 1974/September 11, 1978. Neon de Suro, Palma de Mallorca, 1978

Yesterday/Today/Tomorrow, Urban Landscape Series, The Institute for Urban Resources Inc., New York, 1979

GINÉS SERRÁN PAGÁN

SELECTED BIBLIOGRAPHY

By Serrán Pagán
Publications

"Los factores sociológico y psicológico y el estudio antropológico de los símbolos," *Arbor* (Madrid), no. 362, 1976, pp. 27-40

"Notas de Antropología Simbólica en Africa: Poder y estructura de los símbolos," *Revista Internacional de Sociología* (Madrid), nos. 18-20, 1976, pp. 109-121

Social Anthropology in Andalousia, M.A. Thesis, Department of Anthropology, New York University, 1976

"El Ritual del Toro en España: Algunos errores de análisis y método," *Revista de Estudio Sociales* (Madrid), no. 20, 1977, pp. 87-99

"Educación y Antropología Social: Notas sobre la relación existente entre el sistema educativo y los organismos que ejercen el poder," *Arbor* (Madrid), nos. 391-392, 1978, pp. 65-80

"Dimensiones políticas del cambio social," *Revista Internacional de Sociología* (Madrid), no. 27, 1978, pp. 417-439

"El Toro de la Virgen y la industria textil en Grazalema: Transformación económica y cambios en el mundo simbólico de un pueblo andaluz," *Revista Española de Investigaciones Sociológicas* (Madrid), no. 5, 1979, pp. 119-135

"La fabula de Alcalá y la realidad histórica en Grazalema: Replanteamiento del primer estudio de Antropología Social en España," *Revista Española de Investigaciones Sociológicas* (Madrid), 1979

"Cultura local e ideología política: Anarquismo y Guerra Civil en Grazalema," *Arbor* (Madrid), 1979

Lectures and Presentations

Galería Vandrés, Madrid, "Intro-
ducción al Proyecto Pamplona-
Grazalema," 1977

Universidad de Sevilla, "Antro-
pología en Grazalema," 1977

Círculo Cultural, Casa de España,
New York, "Simbolismo del toro
en España," 1978

The City University of New York,
"The Bull of the Virgin and the
Textile Industry of Grazalema,"
1978

28.
Pamplona-Grazalema. 1975-80
Installation: videotape, film, slides
and related material
Publication: texts, photographs and
graphics

green

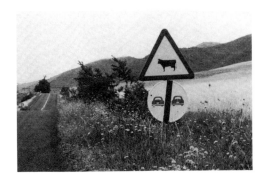

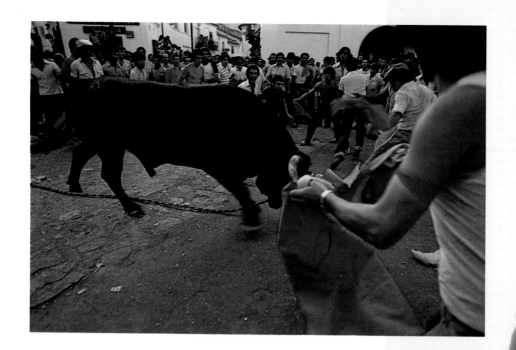

red

MIQUEL NAVARRO

My art consists, fundamentally, in constructing: I construct objects and spaces (environments, architectures and sculptures). My intention is to confer on my work connotations that are atemporal, rational, historical, biographical. The work is executed primarily in clay, although it could include any kind of materials. Clay plays a major role because of its connections with the cultural and industrial beginnings of our civilization. I would also like to add that my work is a philosophical and therefore poetic investigation of the image itself.

Born in Mislata (Valencia), 1945
Studied at Escuela Superior de Bellas Artes de San Carlos, Valencia
Began his career as a painter; since 1972 has devoted himself entirely to sculpture
Lives in Mislata

SELECTED GROUP EXHIBITIONS

Círculo Universitario de Valencia, *Nuestro Yo*, January 15-31, 1969

Galería Val i 30, Valencia, *Once Pintores*, April 15, 1972

Centro de Arte M 11, Seville, *Pintura Española Actual*, June 1974

Galerías Punto, Temps, Val i 30, Valencia, *Els Altres 75 Anys de Pintura Valenciana*, April-July 1976. Traveled in Spain

Galería Ponce, Madrid, *Cinco Ceramistas*, January-February 1977. Catalogue

Caja de Ahorros de Alicante y Murcia, Alicante, *Alaminos, Alcolea, Criado, Lootz, Navarro, Navarro, Baldweg, Serrano, Utray, Valcarel, Medina*, March 1977. Catalogue

Galería Sen, Madrid, *Seis Artistas Valencianos*, October 28-November 22, 1977

Staatliche Kunsthalle Berlin, *Katalanische Kunst des 20. Jahrhunderts*, June 25-August 23, 1978. Catalogue

Galería Juana de Aizpuru, Seville, *Homenaje a Joseph Cornell*, December 20, 1978-January 15, 1979

ONE-MAN EXHIBITIONS

Galería Tassili, Oviedo [with Ramirez Blanco], 1972

Sala de Arte de la Caja de Ahorros Municipal de Pamplona [with Molina Ciges], May 14-22, 1973

Galería Val i 30, Valencia [with Ramirez Blanco], June 12, 1973

Colegio de Arquitectos de Valencia y Murcia, Valencia, *La Ciudad*, November 18-December 3, 1974

Galería Buades, Madrid, *La Ciudad*, March 17, 1975. Catalogue

Galería Temps, Valencia [with Carmen Calvo], November 16-December 16, 1976. Catalogue

Galería Buades, Madrid, February 22, 1977. Catalogue

Galería Juana de Aizpuru, Seville, November 22-December 24, 1977

Galería Vandrés, Madrid, November 15-December 15, 1979. Catalogue

SELECTED BIBLIOGRAPHY

Newspapers and Periodicals

Trinidad Simo, "Miquel Navarro y la Ciudad Fantástica," *Las Provincias* (Valencia), November 24, 1974

José Luis Segui, "Miquel Navarro en el Colegio de Arquitectos," *Record* (Valencia), November 1974

F. Samaniego, "Miquel Navarro y su replanteamiento de la Escultura," *Informaciones* (Madrid), March 31, 1975, p. 16

José Castro Arines, "Dos Nuevas Ciudades," *Informaciones* (Madrid), April 3, 1975, p. 14

Mercedes Lazo, "Al filo de la Cerámica," *Cambio 16* (Madrid), no. 176, April 21, 1975, p. 97

Luis Mañez, "Carmen Calvo y Miquel Navarro," *Dos y Dos* (Valencia), no. 27/28, November 28, 1976

Melia R. Ventura, "Avantguarda i argueología," *AVUI* (Barcelona), December 12, 1976

Eduardo Chávarri Andujar, "Dos Vertientes de la Pintura Valenciana: El Maestro Furio y el Tandem Carmen Calvo—Miquel Navarro," *Las Provincias* (Valencia), December 21, 1976

Juan M. Bonet, "Corto viaje a Valencia y a su pintura," *El País* (Madrid), December 23, 1976

José Garneria, "Carmen Calvo y Miquel Navarro," *Artes Plásticas* (Barcelona), no. 14, December 1976, p. 48

Santiago Amon, "Miquel Navarro," *El País* (Madrid), February 24, 1977, p. 22

Eduardo Alaminos, "Miquel Navarro," *Artes Plásticas* (Barcelona), no. 16, March-April, 1977, pp. 71-72

Fernando Huici, "Seis artistas valencianos," *El País* (Madrid), November 3, 1977, p. 26

Victoria Combalia, "Una nueva generación valenciana. Arqueología y autoreflexión de una prática," *Batik* (Barcelona), no. 45, November 1978, pp. 18-19

Victoria Combalia, Alicia Suarez and Merce Vidal, "Tot sobre les setmanes catalanes a Berlin," *Artilugi* (Barcelona), no. 4, 1978, pp. 1-4

Manuel García i García, "Notas sobre la pintura valenciana de los setenta," *Batik* (Barcelona), no. 50, July-August 1979, pp. 43-45

Antonio Bonet Correa, "Prodigos y maravillas de Miquel Navarro," *Artequía* (Madrid), no. 51, November 30, 1979, pp. 18-19

Book

Manuel Mas, ed., *Gran Enciclopedia de la Región Valenciana*, Valencia, 1972, vol. VII, p. 303

29.
Cylinder. 1974-77
(Cilindro)
Plaster and stoneware, 9⅞ x 17½ x
15¾" (25 x 44.5 x 40 cm.)
Collection the artist

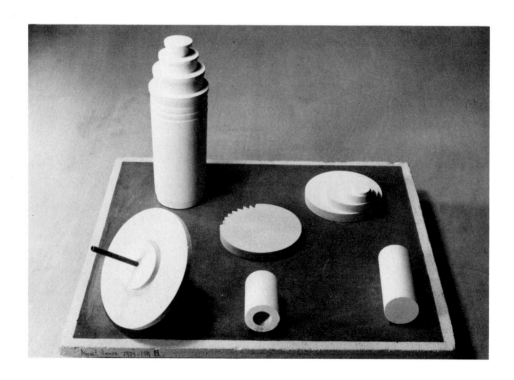

30.
Construction. 1976-77
(Construcción)
Plaster, terra-cotta and stoneware,
14½ x 17½ x 15¾″ (37 x 44.5 x
40 cm.)
Collection the artist

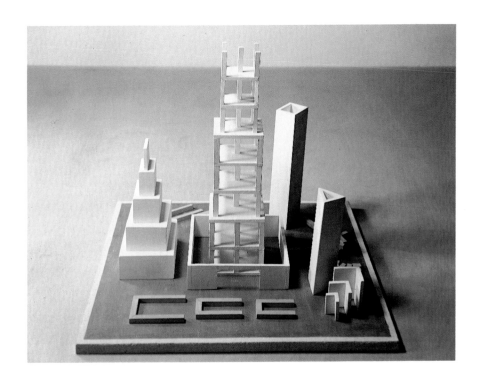

31.
Chimney. 1978-79
(Chimenea)
Stoneware and electrical apparatus,
39⅜ x 39⅜ x 15¾" (100 x 100 x 40
cm.)
Private Collection, Madrid

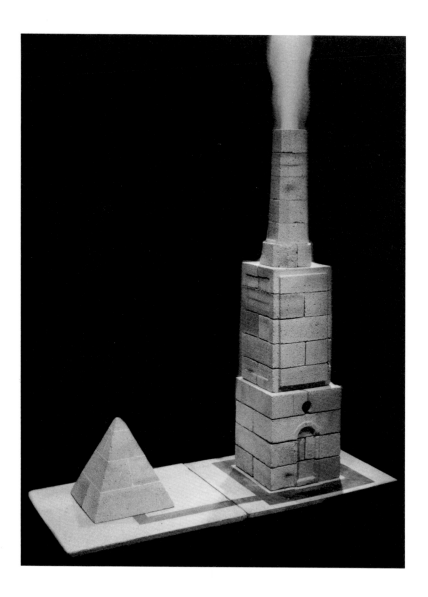

32.
Chapel and Cosmos. 1978
(Capilla y cosmos)
Stoneware and terra-cotta mounted
on wood panel, 43½ x 31½ x 2½"
(110 x 80 x 6.5 cm.)
Private Collection, Paris

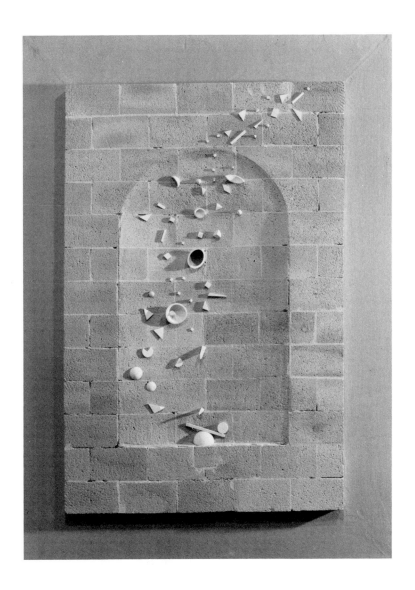

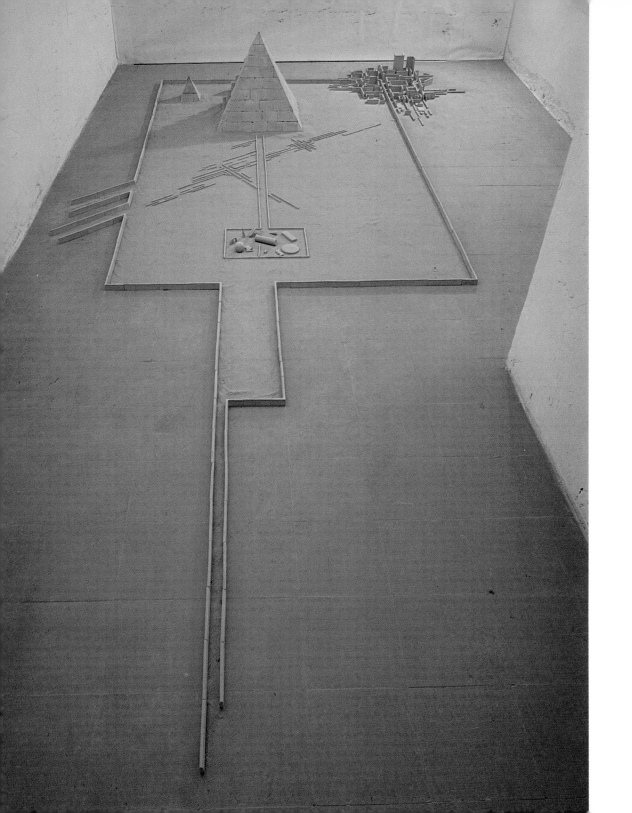

33.
Pyramid. 1977-79
(Pyramide)
Stoneware, terra-cotta and sand,
24¾ x 237 x 106½" (63 x 600 x 270
cm.)
Collection the artist

34.
Prickly Pear. 1979
(Figa Palera)
Terra-cotta mounted on wood
panel, 59 x 41⅜ x 3½" (150 x 105 x
9 cm.)
Collection the artist

35.
Hieroglyphic. 1979
(Jeroglífico)
Terra-cotta mounted on wood
panel, 59 x 59 x 2¾" (150 x 150 x
7 cm.)
Collection the artist

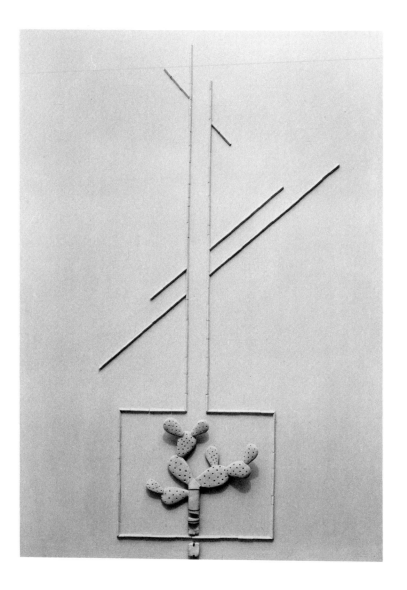

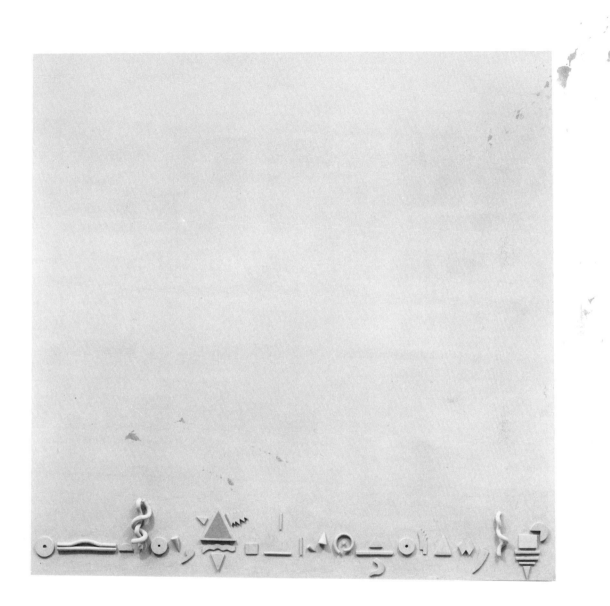

36.
Ball-tipped Horns. 1979
(Bou embolat)
Terra-cotta mounted on wood panel, 59 x 41⅜ x 3⅞" (150 x 105 x 10 cm.)
Collection J. Suñol, Barcelona

37.
Beginning 1. 1979
(Origen 1)
Terra-cotta mounted on wood panel, 59 x 59 x 3⅛" (150 x 150 x 8 cm.)
Collection the artist

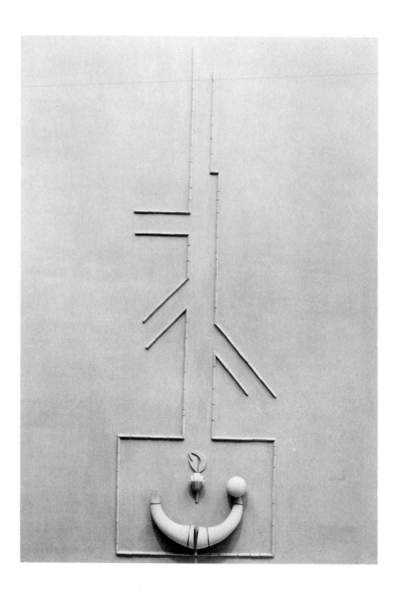

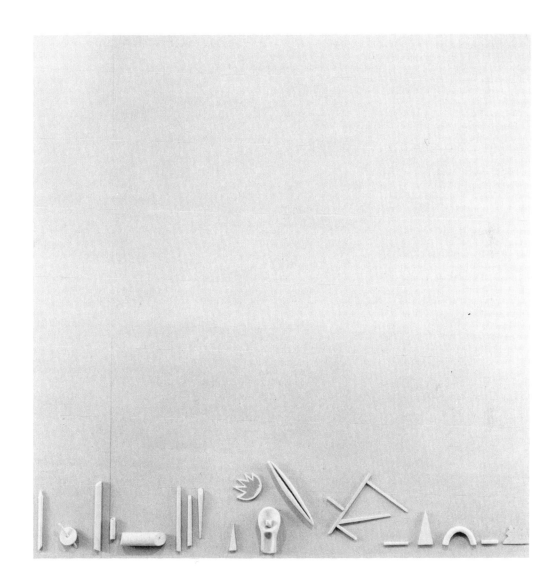

38.
Beginning 2. 1979
(Origen 2)
Terra-cotta mounted on wood
panel, 59 x 41⅜ x 2¾″ (150 x 105 x
7 cm.)
Collection Lambert, Brussels

39.
Cactus. 1979
Stoneware, terra-cotta and sand,
10¼ x 19¾ x 19¾″ (26 x 50 x 50
cm.)
Collection the artist

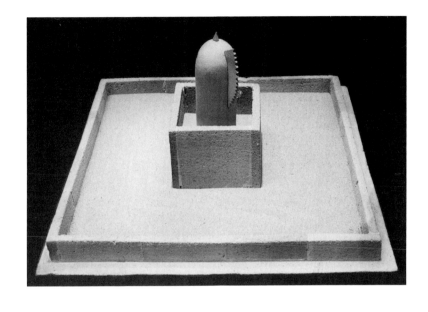

40.
Cosmos. 1979
Stoneware, terra-cotta and black
sand, 3⅜ x 19¾ x 19¾″ (8.5 x 50 x
50 cm.)
Collection the artist

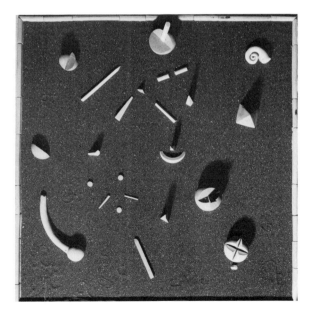

GUILLERMO PÉREZ VILLALTA

Born in Tarifa, 1948
Self-taught as a painter; began painting in 1965
Studied architecture from 1966
Lives in Madrid

The act of artistic creation is, for me, completely fused with my own life which is, without a doubt, my only oeuvre. What I see, where I am, my reading, music and travels form part of it. I do not attempt to clarify anything. Chaos itself, confusion or contradiction are for me fundamental. Therefore all possibilities overlap and interweave in my work: polystylism is my technique. Abstraction, mannerism, the baroque, and even pompier art, can serve as an Ariadne's thread for this labyrinth. It is only a matter of letting time pass.

SELECTED GROUP EXHIBITIONS

Lunds Konsthall, Lund, Sweden, *Spanskt*, November 10-December 9, 1973

Galería Buades, Madrid, *Exposición Inaugural Galería Buades*, November 1973

Galería Buades, Madrid, *Sesiones de Trabajo: El Taller / La Pintura / El Museo*, February 6-19, 1974

Casa Damas, Seville, *Siete Pintores*, March 1974

Centro de Arte M 11, Seville, *Pintura Española Actual*, June 1974

Museo Provincial, Cádiz, *Arte Cádiz*, June 1974

Galería Juana de Aizpuru, Seville, *A los 50 años del Surrealismo*, January 9-31, 1975

Casa Damas, Seville, *El Cepillo*, March-April 1975

Galería Vandrés, Madrid, *Vandrés 1970-1975*, December 11, 1975-January 10, 1976

Barcelona, *Arte-Expo*, November 6-14, 1976

Galería El Coleccionista, Madrid, *Siete Pintores en torno a la Ciudad*, November 1976

Provincial Museum of Modern Art, Hyogo, Japan, *Exposición de Pintura Española desde el Renacimiento hasta nuestros Días*, 1976. Traveled to Metropolitan Museum of Art, Tokyo; Kitakyushu Municipal Museum of Art

Galería Laietana, Barcelona, *El Mar y la Pintura*, May 1978

Galería Ponce, Madrid, *Pintores Marginales*, June 2-30, 1978

Galería Juana de Aizpuru, Seville, *Homenaje a Joseph Cornell*, December 20, 1978-January 15, 1979

Galería Ovidio, Madrid, *El Lápiz señala al Asesino*, March 1979

Galería Estampa, Madrid, *Interiores*, June 1979

Galería Ruiz Castillo, Madrid, *Obra sobre papel*, June 1979

Galería Juana de Aizpuru, Seville, *Dibujos de Artistas Españoles Contemporáneos*, July-September 1979

Galería Juana Mordó, Madrid, *1980*, October 10-November 18, 1979

ONE-MAN EXHIBITIONS

Galería Amadis, Madrid, January 8-20, 1972. Catalogue

Galería Trajano, Seville, *Relaciones entre Imágenes y Algunos Ornamentos*, April 8, 1972

Galería La Mandrágora, Málaga, October 27-November 15, 1972

Galería Daniel, Madrid, March 2-24, 1973

Galería Juana de Aizpuru, Seville, November 27-December 18, 1973

Galería Buades, Madrid, March 16-April 6, 1974

Galería Vandrés, Madrid, April 27-May 22, 1976. Catalogue

Galería Buades, Madrid [with Chema Cobo], March 22-April 17, 1977. Catalogue
Galería Vandrés, Madrid, October 9-November 10, 1979. Catalogue

SELECTED BIBLIOGRAPHY
Newspapers and Periodicals

Juan de Hix [Juan M. Bonet], "Las Mitologí as Diversas de Pérez Villalta," *El Correo de Andalucia* (Seville), April 22, 1972, p. 17

"Guillermo Pérez Villalta en la Sala Mandrágora," *El Sur* (Málaga), November 17, 1972, pp. 12-17

Carlos Marrero, "Guillermo Pérez Villalta," *Bellas Artes* (Madrid), no. 33, May 1974, pp. 50-51

Juan Pedro Quiñoneros, "En busca de un Nuevo Arte Mediterráneo," *Informaciones* (Madrid), May 11, 1976

Juan M. Bonet, "Pérez Villalta, en una posible generación," *El País* (Madrid), May 16, 1976, p. 23

Francisco Rivas, "Pérez Villalta: unas Nuevas 'Señoritas de Avignon'?," *Batik* (Barcelona), May 1976, pp. 16-17

José Marín-Medina, "Pérez Villalta: de la libertad a voluntad de poder," *Gazeta del Arte* (Madrid), no. 79, June 6, 1976, pp. 16-17

Eduardo Alaminos, "Guillermo Pérez Villalta: ¿un tríptico, un escenario, un retrato?," *Artes Plásticas* (Barcelona), no. 9, June 1976, pp. 25-27

Fernando Savater, "Discreción y prodigio en Guillermo Pérez Villalta," *Ozono* (Madrid), no. 10, June 1976, p. 59

Juan M. Bonet, "Chema Cobo y G. Pérez Villalta," *El País* (Madrid), April 7, 1977, p. 17

Juan Antonio Aguirre, "1967-77 Primera Parte," *Bellas Artes* (Madrid), no. 56, April 1977, pp. 50-51

Mariano Navarro, "Imagen pública/imágenes privadas," *Ozono* (Madrid), no. 20, May 1977, pp. 46-48

Fernando Huici, "En el Lugar del Recuerdo," *Zoom* (Madrid), no. 6, June 1977

Fernando Huici, "Guillermo Pérez Villalta," *El País* (Madrid), October 11, 1979, p. 27

Miguel Logroño, "Fray Angelico, Pérez Villalta," *Diario 16* (Madrid), October 17, 1979

Santos Amestoy, "Pérez Villalta: salutación al optimista," *Arteguía* (Madrid), no. 50, October 30, 1979, pp. 29-30

Miguel Fernandez-Braso, "Pérez Villalta: el nuevo realismo español," *Guadalimar* (Madrid), no. 45, October 1979, pp. 48-51

Felix Guisasola, "La figuración hoy: Pérez Villalta," *Sábado Gráfico* (Madrid), November 7, 1979, p. 47

María Teresa Blanch, "G. Pérez Villalta, revisión y audacia," *Batik* (Barcelona), no. 51, November 1979, pp. 64-65

Books

Raul Chávarri, *La Pintura Española Actual*, Madrid, 1973, p. 415

Simon Marchan Fiz, *Del arte objectual al arte conceptual 1960-1974*, Madrid, 1974, p. 337

V. Bozal and T. Llorens, eds., *España. Vanguardia artística y realidad social: 1936-1976*, 1976, pp. 182-184

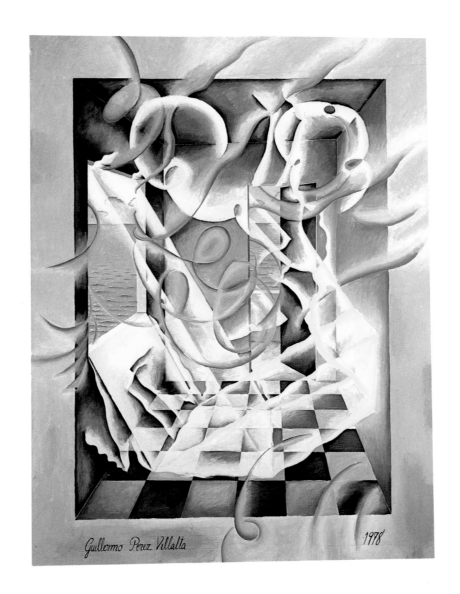

Guillermo Perez Villalta 1978

41.

Sun Entering a Drafty Room. 1978
*(Sol entrando en una habitación
con corrientes de aire)*
Acrylic on canvas, 55⅛ x 43¼″
(140 x 110 cm.)
Lent by Galería Vandrés, Madrid

42.

Distance is Forgetfulness. 1978
(La Distancia es el olvido)
Acrylic on canvas, 55⅛ x 43¼″
(140 x 110 cm.)
Lent by Galería Vandrés, Madrid

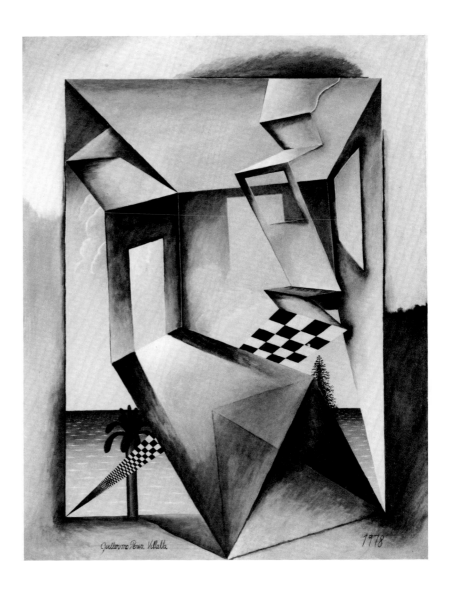

43.

The Annunciation or *The Meeting.*
1978
(La Anunciación o El Encuentro)

Acrylic on canvas, 3 panels, 39⅜ x
39⅜" (100 x 100 cm.); 39⅜ x 7⅞"
(100 x 20 cm.); 39⅜ x 39⅜" (100 x
100 cm.)

Private Collection, Madrid

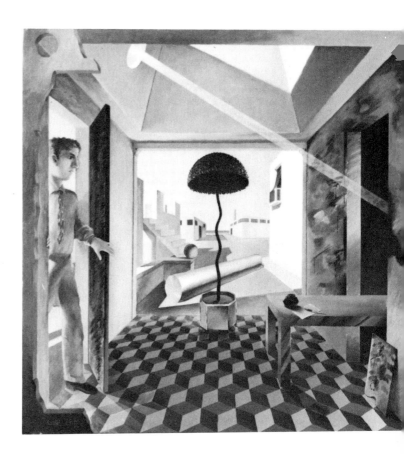

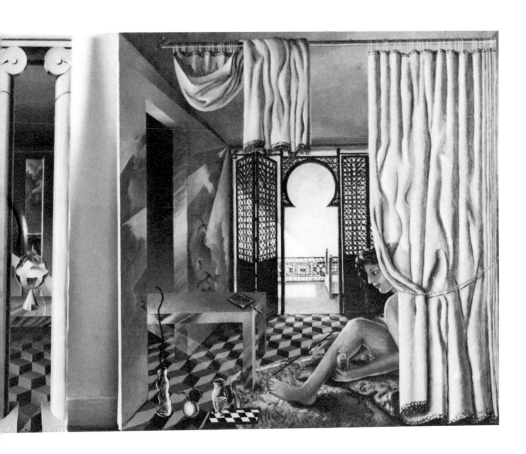

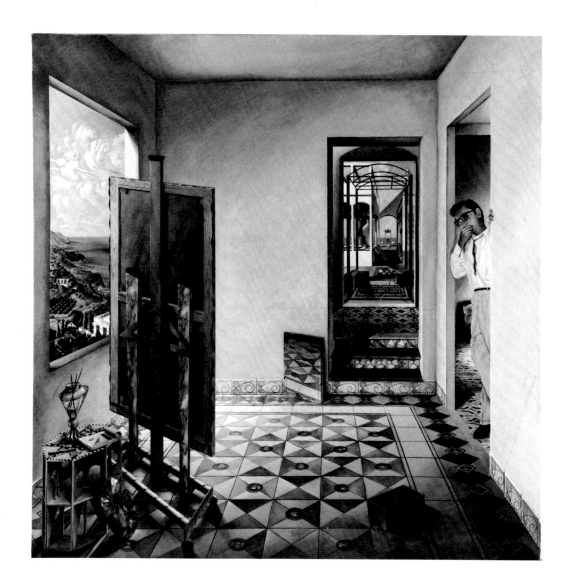

44.
The Studio. 1979
(El Taller)
Acrylic on canvas, 70⅞ x 70⅞"
(180 x 180 cm.)
Collection J. Suñol, Barcelona

45.
In Octu oculi. 1979
Acrylic on canvas, 55⅛ x 70⅞"
(140 x 180 cm.)
Collection the artist

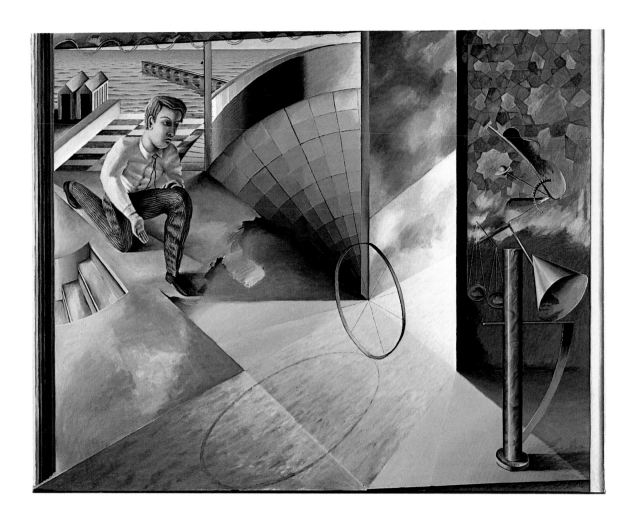

46.
Ecstasy During the Siesta. 1979
(Extasis en la siesta)
Acrylic on canvas, 39⅜ x 39⅜″
(100 x 100 cm.)
Collection J. Suñol, Barcelona

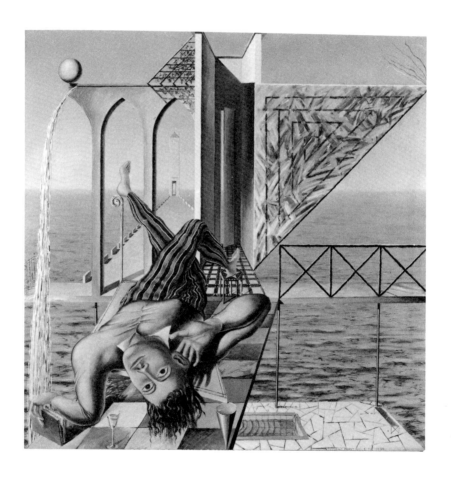

JORGE TEIXIDOR

Born in Valencia, 1941
Studied at Escuela Superior de Bellas
Artes de San Carlos, Valencia
1959-64
Juan March Foundation Grant to
work in New York, 1979-80
Lives in Valencia

I began the white series of 1977 for reasons of method. I had begun to sense too much facility in my use of color, which I wanted to avoid. As I had hoped but not expected, the result was an affirmation of the pictorial act. The canvases became limit-paintings, as the emphasis shifted from the idea of a particular work to the act of painting itself. The process of execution conveyed and respected pictorialism in its own language. In a deliberate way I worked as much on the absence of color as on the minimal and concise formal space in which it acted. Because each painting evolved from the previous one and forecast the next, the series had a unified appearance.

The series of white paintings ended for the same reasons that it began. I took up color again, or more precisely, I introduced scales of colors. The selection of each scale was not so important as the manner in which I worked within it. The horizontal bands across the width of the canvas responded to an anonymous method, which could not be modified—or could only be minimally modified—by action. At the same time, once the overall color was chosen for these virtually monochrome pictures, there were still slight differences in value and contrast. The use of yellow in the series was deliberate. Undoubtedly, every color has a connotative character, and it is commonly held that there are certain psychoanalytic or cultural reasons for this. Thus it is said that green represents hope and that red represents passion and even the political ideology of the left. My choice of yellow was not motivated by ideological considerations or popular beliefs. Cultural connections, however, could be deduced from the series (as in some of the pictures based on the *Mimosa* of Bonnard), as well as psychological interpretations. The use of yellow was important to me in that it represented my decision to accept color again after its absence in the white series. Also, yellow is different from other colors because of its relative neutrality. This color was sometimes replaced by a scale of violets.

My interest in American abstract painting of the last three decades continued throughout these last two series. Occasionally there has even been a formal similarity. The attitude toward the act of painting, my recognition of the consequences of this act, the theoretical reduction and the supremacy of color as a specific language have been (in my own interpretation of the phenomenon and in a cultural context) the foundations on which I have been building my formulations for the last five years.

SELECTED GROUP EXHIBITIONS

Galería Edurne, Madrid, *Nueva Generación*, 1967

Galería Eurocasa, Madrid, *Antes del Arte*, 1968

Colegio de Arquitectos, Bilboa, *Mente IV*, 1969

Galería AS, Barcelona, *Antes del Arte*, 1969

Galería La Pasarella, Seville, *Antes del Arte: Serie Matemáticas*, 1970

Galería Juana de Aizpuru, Seville, *Homenaje a Marcel Duchamp*, 1971

Granollérs, Spain, *Arte Joven*, 1971

Museo de Arte Contemporáneo, Seville, *Arte valenciano actual*, 1972

Sala Gaspar, Barcelona, *Homenaje a Joan Miró*, 1973

Lunds Konsthall, Lund, Sweden, *Spanskt*, November 10-December 9, 1973

Galería Buades, Madrid, *10 Abstractos*, July 1975. Catalogue

Galería Ponce, Mexico City, *22 Artistas Catalanes*, 1975

Galería Durango y Zaragoza, Valladolid, Spain, *Broto, Grau, León, Teixidor y Tena*, February 3-14, 1976

Galerías Punto, Temps. Val i 30, Valencia, *Els Altres 75 Anys de Pintura Valenciana*, April-July 1976. Traveled in Spain

Venice, *Biennale Internazionale d'Arte, Spagna: Vanguarda Artistica, Realtà Sociale*, June-October 1976. Catalogue

Fundació Joan Miró, Barcelona, *Pintura I*, 1976

Staatliche Kunsthalle Berlin, *Katalanische Kunst des 20. Jahrhunderts*, June 25-August 23, 1978. Catalogue

Galería Juana de Aizpuru, Seville, *Homenaje a Cornell*, December 20, 1978-January 15, 1979

Musée d'Art et d'Industries, Saint-Etienne, France, *Impact 3*, 1978

Centro Cultural de los EE. UU., Madrid, *Pintura abstracta*, 1979

SELECTED ONE-MAN EXHIBITIONS

Sala Mateu, Valencia, February 1966

Galería Edurne, Madrid, March 1968. Catalogue

Galería Daniel, Madrid, November 11-December 4, 1970

Galería Grises, Bilboa, 1970

Galería Val i 30, Valencia, March-April 1971

Galería Juana de Aizpuru, Seville, October 1971

Galería Honda, Cuenca, 1971

Galería Sen, Madrid, October 3-30, 1972

Galería Atenas, Zaragoza, 1972

Galería Val i 30, Valencia, 1973

Galería Temps, Valencia, September 24-October 20, 1974

Galería Barbie, Barcelona, March-April 1975. Catalogue

Galería Dach, Bilboa, October 15-November 7, 1975

Galería Vandrés, Madrid, November 4-29, 1975

Galería Rua, Santander, Spain, 1975

Galería Juana de Aizpuru, Seville, January 12-31, 1977

Galería Vandrés, Madrid, November-December 1977

Galería Viciana, Valencia, November 22-December 1978. Catalogue

Galería Joan Prats, Barcelona, *Jordi Teixidor: Pinturas 1976-1979*, May 15, 1979. Catalogue

Galería Sa Pleta Freda, Son Servera, July 14-August 3, 1979

SELECTED BIBLIOGRAPHY

Newspapers and Periodicals

Raul Chávarri, Tres Comentarios sobre Arte," *Cuadernos Hispanoamericanos*, no. 230, 1969, pp. 454-457

Juan Antonio Aguirre, "J. Teixidor: Desde 'las puertas' a las 'Aperspectivas,'" *El Correo de Andalucia* (Seville), December 3, 1970, p. 19

Allanza, "Conversaciones con Teixidor," *El Correo de Andalucia* (Seville), December 3, 1970, p. 19

Juan Hix [Juan M. Bonet] and Francisco Jordan [F. Rivas], Conversación con Jorge Teixidor," *El Correo de Andalucia* (Seville), October 9, 1971, p. 13

Ricardo Bellevese, "Jordi Teixidor: Reflexión en colores, sobre el lenguaje," *Las Provincias* (Valencia), September 25, 1974

Joaquin Dols, "Jordi Teixidor en Galería Barbie," *Galería* (Barcelona), no. 5, April 1975, pp. 61-62

Daniel Giralt-Miracle, "Jordi Teixidor: De la estructura racional a la estructura natural," *Destino* (Barcelona), no. 1957, April 1975, pp. 34-35

Daniel Giralt-Miracle, "Naturaleza y Artificio en la Obra de Jordi Teixidor," *Batik* (Barcelona), no. 14, April 1975, pp. 14-15

Trinidad Simo, "Jorge Teixidor. La Soledad y la Esperanza: El Paso hacia la poesía lírica," *Galería* (Barcelona), no. 8, July-August 1975, pp. 11-13

Dámaso Santos Amestoy, "Jordi Teixidor," *Galería* (Barcelona), no. 11, December 11, 1975, p. 34

Juan M. Bonet, "Ilusiones de tendencia. Pintura I en la Fundació Miró de Barcelona," *El País* (Madrid), November 7, 1976, p. 20

Ramon Torres Martin, "Monis Mora, Teixidor y Manuel Sanchez," *El Correo de Andalucia* (Seville), January 19, 1977, p. 13

Francisco Rivas, "Teixidor," *El País* (Madrid), March 3, 1977, p. 24

Santiago Amon, "Teixidor: relación y evocación de la luz," *El País* (Madrid), November 24, 1977, p. 28

Fernando Huici, "Jordi Teixidor en el blanco," *Batik* (Barcelona), no. 37, November 1977, p. 41

Pancho Ortuña and Francisco Rivas, "Conversación con Jordi Teixidor," *Arteguía* (Madrid), no. 32, December 1977, p. 50

"Teixidor," *Guadalimar* (Madrid), no. 27, December 1977, p. 90

Manuel García, "El ritual de Jorge Teixidor," *Valencia Semanal* (Valencia), December 17, 1978, p. 37

Hilton Kramer, "Painters and Politics in the New Spain," *The New York Times*, June 3, 1979, pp. D 1, D 27. Reprinted as "Contrasts in Barcelona: Two Promising Painters," *International Herald Tribune* (London), June 16-17, 1979, p. 9

Aurora García, "Jordi Teixidor: una poética del silencio," *Batik* (Barcelona), no. 50, June 1979, pp. 50-51

Javier Rubio Navarro, "Jordi Teixidor y Geraldo Delgado, en Barcelona," *El País* (Madrid), July 5, 1979, p. 29

Gloria Moure, "Jordi Teixidor: autonomía del lenguaje pictórico," *Cimal* (Gandía), no. 4, July-August 1979, pp. 48-52

Books

Juan Antonio Aguirre, *Arte Ultimo*, Madrid, 1969, pp. 49-53

Manuel Mas, ed., *Gran Enciclopedia de la Región Valenciana*, Valencia, 1972, vol. II, p. 188

William Dyckes, ed., *Contemporary Spanish Art*, New York, 1975, pp. 54-55, 104, 127

V. Bozal and T. Llorens, eds., *España. Vanguardia artística y realidad: 1936-1976*, Barcelona, 1976, pp. 167, 184-185

47.
Painting with Gray and Blue. 1975
(Pintura con gris y azul)
Acrylic and oil on canvas, 70⅞ x
51⅛" (180 x 130 cm.)
Collection Gloria Kirby, Madrid

48.
Untitled. 1976
(Sin título)
Acrylic and oil on canvas, 70⅞ x
51⅛" (180 x 130 cm.)
Lent by Galería Vandrés, Madrid

49.
Untitled. 1977
(Sin título)
Acrylic and oil on canvas, 70⅞ x
51⅛″ (180 x 130 cm.)
Collection the artist

50.
Yellow Bands 1. 1978
(Bandas amarillas 1)
Oil on canvas, 70⅞ x 51⅛″ (180 x
130 cm.)
Collection Museo de Arte Abstracto,
Cuenca, Spain

51.
Yellow Bands 2. 1978
(Bandas amarillas 2)
Oil on canvas, 70⅞ x 51⅛″ (180 x
130 cm.)
Collection J. Suñol, Barcelona

52.
Yellow Mimosa. 1978
(Amarillo Mimosa)
Oil on canvas, 70⅞ x 51⅛″ (180 x
130 cm.)
Collection J. Suñol, Barcelona

DARÍO VILLALBA

My work since 1964 has been concentrated on the image. I felt the need to break with Spanish abstract informalism. My main focus is life and, more specifically, human beings. Fundamental realities. Non-intellectualized feelings.

In 1967 I began my encapsulations, which were shown at the Venice Biennale. I enclosed man in transparent plexiglass chrysalids, freeing the picture from the traditional support to locate it in three-dimensional space.

The image I invented emerges like a bubble, a second technological skin that surrounds man and makes his inability to communicate more blatant.

During the last decade the content of my work has gradually become more specific. Detachment coexists with emotiveness. In my most recent works this dualism is fused. This leads me to a more vital and visible manual involvement with the picture.

It is obvious that the verbal explanations I make of work that is as intense as mine can only be detrimental to its interpretation.

Born in San Sebastián (Basque region), 1939
Lived in Boston, 1950-54, 1958-62
Studied with André Lhote in Paris, 1958; Harvard University (Department of Fine Arts), Cambridge, Massachusetts, 1958-62; Escuela Superior de Bellas Artes de San Fernando, Madrid, 1962-64; Universidad de Madrid (Philosophy and Letters)
Lives in Madrid

SELECTED GROUP EXHIBITIONS

World's Fair, New York, *Pintura Española Contemporánea*, 1964

Galería El Bosco, Madrid, *Cinco Pintores Españoles en la VII Bienal de São Paulo*, 1965

Museo Español de Arte Contemporáneo, Madrid, *Testimonio 70*, March 1970. Traveled to Cologne; Montpellier; London; The Netherlands

Museum voor Schone Kunsten, Ghent, *Jonge Spaanse Kunst*, May 15-June 15, 1971

VII Biennale de Paris, September 24-November 1, 1971

Galería Vandrés, Madrid, *La Paloma*, June 5-July 31, 1972

Musée d'Art Moderne (Musée Experimental III), Lausanne, *Implosion*, November 3-December 10, 1972

Medellín, Colombia, *Bienal de Medellín*, 1972

Musée d'Art Moderne, Paris, *Salon de mai*, 1972, 1973

Lunds Konsthall, Lund, Sweden, *Spanskt*, November 10-December 9, 1973

Pavillon d'Exposition Bastille, Paris, *Premier Salon International d'Art Contemporain*, January 26-February 3, 1974

Musées Royaux des Beaux-Arts, Brussels, *Art Espagnol d'Aujourd' hui*, June 6-July 14, 1974 Catalogue

Haus der Kunst, Spanisches Kulturinstitut, Munich, *Spanische Kunst Heute*, August 31-October 6, 1974

XIII Bienal de São Paulo, October-December 1975. Catalogue

Galería Ponce, Mexico City, *Realismos en España*, October-December 1975

Galería Vandrés, Madrid, *Vandrés 1970-1975*, December 11, 1975-January 10, 1976

Galería Biosca, Madrid, *75 años de escultura en España*, 1975

Provincial Museum of Modern Art Hyogo, Japan, *Exposición de Pintura Española desde el Renacimineto hasta nuestros Días*, 1976. Traveled to Metropolitan Museum of Art, Tokyo; Kitakyushu Municipal Museum of Art

Künstlerhaus, Vienna, *K45-International Fair of the Avantgarde*, February 17-21, 1977

Fundació Joan Miró, Barcelona, *Homenaje a Allende*, 1977

Fundaçiõ Gulbenkian, Lisbon, *Pintura Española*, 1978

Museo de Arte Contemporáneo de Madrid, *Panorama 78*, 1978

Muzeum Narodowe, Warsaw, *Contemporary Spanish Painting*, May 1979. Traveled to Národní Galerie, Prague, June 21-July 22

XV Bienal Internacional de São Paulo, October 3-November 9, 1979. Catalogue

SELECTED ONE-MAN EXHIBITIONS

Galería El Bosco, Madrid, *Crónica de Palomares*, 1967

Museo Español de Arte Contemporáneo, Madrid, May 1970

Venice, *XXXV Biennale Internazionale d'Arte*, Spanish Pavilion, June 24-October 25, 1970

Galleria del Naviglio, Milan, December 2-13, 1970. Catalogue

Studio C., Brescia, January 16-31, 1971

Galería Ramon Duran, Madrid, June 21-July 6, 1971

Musée de l'Art et de l'Histoire, Geneva, October 4-31, 1971

Deson-Zaks Gallery, Chicago, January 28-February 29, 1972

Galerie Henry Meyer, Lausanne, closed February 17, 1972

XII Bienal de São Paulo, October-December 1973. Catalogue

Espace Pierre Cardin, Paris, November 1973-January 1974

Galería Vandrés, Madrid, April 24-June 10, 1974. Catalogue

Frankfurter Kunstverein, *Darío Villalba: Objekte und Bilder*, June 28-August 11, 1974

Kölner Kunstmarkt, Cologne, October 19-24, 1974

Louisiana Museum, Humlebaek, Denmark, January 18-February 23, 1975. Catalogue

Museum Boymans-van Beuningen, Rotterdam, May 30-July 14, 1975

Basel, International Art Fair, *Art 6-75*, June 18-24, 1975

Stadtmuseum Bochum, Germany, September 12-October 19, 1975. Traveled to Heidelberger Kunstverein, February 22-March 21, 1976. Catalogue

Palais des Beaux-Arts, Brussels, *Darío Villalba: Retrospective 1972-1976*, April 1-30, 1976. Catalogue

Galerie Gras, Vienna, January 15-February 12, 1977

Künstlerhaus Wien, Vienna, January 15-February 6, 1977. Catalogue

Galería Juana Mordó, Madrid, November 7-December 9, 1978

Galería Vandrés, Madrid, *Darío Villalba: Obra 1974-1978—Pintura*, November 9-December 16, 1978. Catalogue

SELECTED BIBLIOGRAPHY

Newspapers and Periodicals

Moreno Galvan, "Dario Villalba. En el museo de Arte Moderno. Madrid," *Triunfo* (Barcelona), June 26, 1971

Jacques-D. Rouiller, "Les Hommes-Bulles de Villalba," *La Gazette littéraire* (Lausanne), May 2, 1972

Elena Florez, "El Pabellon de España en la XII Bienal de São Paulo," *Goya* (Madrid), no. 116, September 1973, pp. 127-128

P. Aguilar, "Premio Bienal São Paulo. Darío Villalba," *ARA*, no. 38, October 11, 1973, pp. 139-144

Miguel Fernandez-Braso, "Darío Villalba, Premio Bienal de São Paulo," *ABC* (Madrid), October 16, 1973

Ramon Chao, "Darío Villalba: una transparencia biológica," *Triunfo* (Barcelona), December 15, 1973

Juan M. Bonet, "Conversation with Darío Villalba," *Flash Art* (Milan), December 1973-January 1974, p. 26

Marta Traba, "Los Ilustradores de la alienación," *Las Provincias* (Valencia), February 2, 1974

María Lluìsa Borràs, "entretien avec Darío Villalba," *L'Art Vivant* (Paris), June 1974, p. 16

José María Moreno "Darío Villalba, en la sala grande de Vandrés," *Triunfo* (Barcelona), August 3, 1974

Pierre Restany, "Darío Villalba: det rene engagement i det eksistentielle vidnesbyrd," *Louisiana Revy* (Humlebaek, Denmark), no. 4, January 18-February 23, 1975, pp. 8-10

Enrique Azcoaga, "Darío Villalba y el Sufrimiento," *Mundo Hispánico*, no. 322, January 1975, pp. 44-47

"Tres análisis ejemplares," *Don Pablo*, May 1976, pp. 39-41

René Micha, "L'Oeuvre noire de Villalba," *Art International*, vol. XXI, January 1977, pp. 20-22

María Lluìsa Borràs, "Darío Villalba: l'art comme processus," *Art Press International*, vol. 4, February 1977, p. 31

Emiel Langui, "Hommage à la douleur," *Artitudes* (Paris), no. 39/44, April-November 1977, pp. 47-48

Santiago Amon, "Darío Villalba," *El País* (Madrid), November 9, 1978, p. 26

María Teresa Casanelles, "Darío Villalba en las galerías Juana Mordó y Vandrés," *El Europeo*, November 21, 1978, p. 50

Mario Merlino, "Darío Villalba: cuerpos y figuras," *Opinión*, November 24, 1978

Victoria Combalia, "La neuva vía de Darío Villalba," *Batik* (Barcelona), no. 46, December 1978

Book

Hans-Jürgen Müller, *Kunst kommt nicht von Können*, Stuttgart, 1976, p. 252

53.
The Wait. 1974
(La Espera)
Photographic emulsion and oil on
canvas with aluminum and perspex,
105⅜ x 70⅞ x 53⅛" (267 x 180 x
135 cm.)
Lent by Galería Vandrés, Madrid

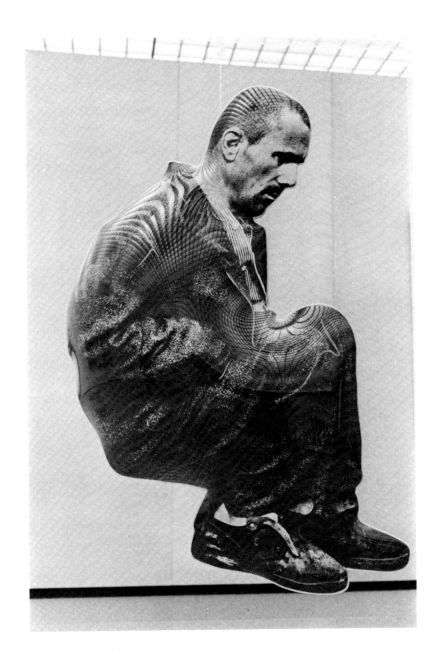

54.
The Wait. 1979
(La Espera)
Photographic emulsion, bituminous
paint, oil and wax on canvas, 3
panels, each 79 x 63" (200 x 160 cm.)
Private Collection, Madrid

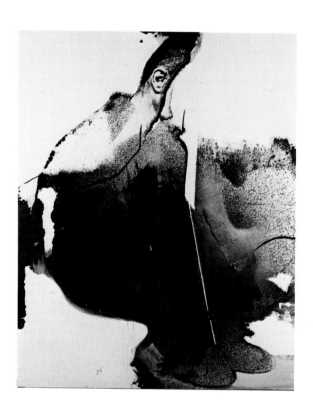

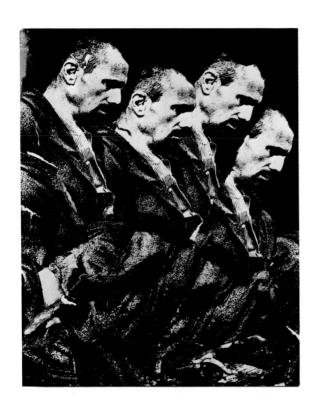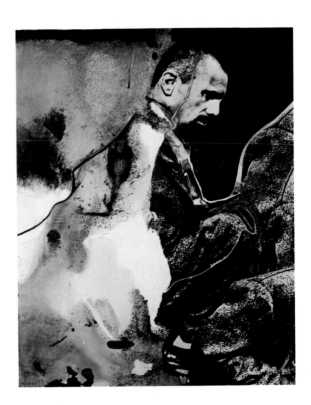

55.
Feet. 1979
(Pies)
Photographic emulsion and oil on
canvas, 79 x 63″ (200 x 160 cm.)
Collection the artist

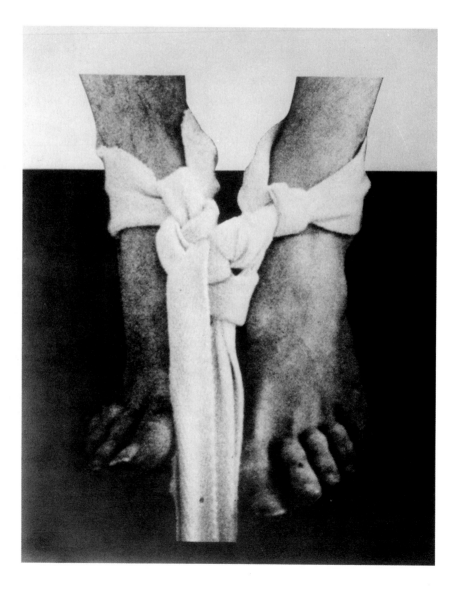

56.
Face 1979. 1979
(Faz 1979)
Photographic emulsion, oil, wax
and pencil on canvas, 79 x 63"
(200 x 160 cm.)
Collection the artist

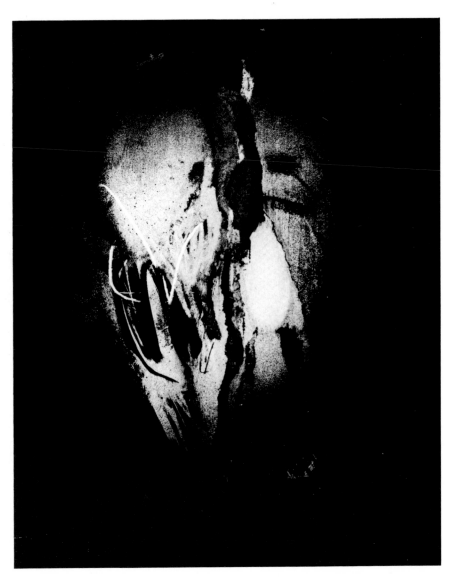

57.
Head I 79. 1979
(Cabeza I 79)
Photographic emulsion, oil, wax
and pencil on canvas, 79 x 63″
(200 x 160 cm.)
Collection J. Suñol, Barcelona

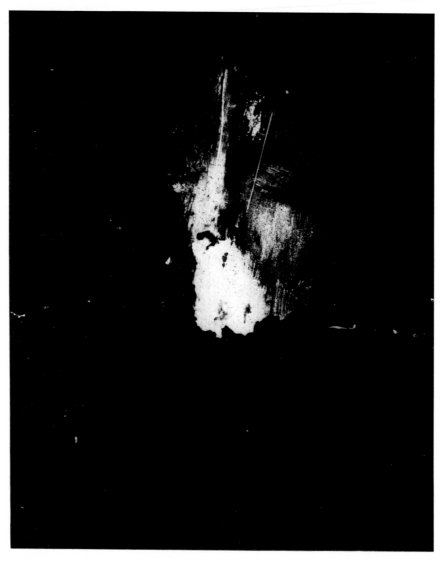

58.
Mystic 79. 1979
(Mistico 79)
Photographic emulsion, oil and wax
on canvas, 79 x 63" (200 x 160 cm.)
Collection the artist

ZUSH

Born Alberto Porta in Barcelona,
1946
Changed name to Zush, 1968
Self-taught as a painter
Moved to Ibiza, 1968
Worked in New York, 1975, 1977
Lives in Ibiza

The rationalization of my work is valid when individual.

THE SYSTEM: A dialogue between my own Language (calligraphy meaningless, meaningful) and universal symbols (eye, world, beings . . .) Can be interpreted as distinct and personal paths.

CONSTANTS OF INVESTIGATION: The materialization of ideas. The biography of my thoughts and feelings transformed into my private mythology. The situation of beings in virtual time.
The fusion of Traditional and Technological visual Media.
The use of Space with and without constants or limits.
The evolution of my language (ANURA).

MY IDEAL: My work to be the essence of all Art extant past present and future.

SELECTED GROUP EXHIBITIONS

Galería René Métras, Barcelona, *Gali, Fried, Porta*, February 9-March 1, 1966
Galería René Métras, Barcelona, *Artigau, Jordi Galí, Porta*, April 7-25, 1967
IX Bienal de São Paulo, September-December 1967. Catalogue
Galería Vandrés, Madrid, *Eros y el Arte Actual en España*, May-June 1971
Galería Vandrés, Madrid, *La Paloma*, June 5-July 31, 1972
IKI, Düsseldorf, *Internationaler Markt für aktuelle kunst neues Messagelände*, October 6-11, 1972
Medellín, Colombia, *III Bienal de Arte Coltejer*, May 1-June 15, 1972
Lunds Konsthall, Lund, Sweden, *Spanskt*, November 10-December 9, 1973
Haus der Kunst, Munich, *Spanische Kunst Heute*, August 31-October 6, 1974. Catalogue
Galería Seiquer, Madrid, *Homenaje al Surrealismo*, January 1975
Galería Vandrés, Madrid, *Vandrés 1970-1975*, December 11, 1975-January 10, 1976

Kassel, Germany, *Documenta 6*, June 24-October 7, 1977. Catalogue
Galería René Métras, Barcelona, *El Collage a Catalunya*, February-March 1978
Galería Ponce, Madrid, *Gráfica, Fantástica*, March 10, 1978
Art Gallery of New South Wales, *Third Biennale of Sydney*, April 12-May 27, 1979
Galerías Ciento, Eude, Joan Prats, Sala Gaspar, Barcelona, *Festa de la Letras*, September 18, 1979
Franklin Institute, Philadelphia, *New Spaces—The Holographer's Vision*, September 26, 1979-March 21, 1980. Catalogue
Stuttgart, *Europa 79*, September 29-October 8, 1979
XV Bienal Internacional de São Paulo, October 3-November 9, 1979

ONE-MAN EXHIBITIONS

Galería René Métras, Barcelona, *Alucinaciones*, November 15-December 10, 1968
Galería Ivan Spence, Ibiza, *Alucinaciones*, July 26, 1969
Galería Seiquer, Madrid, May 5-25, 1970

Galería René Métras, Barcelona, *Ego Zush Production*, October 7-November 4, 1970

Galería Sen, Madrid, *Ego Zush Production*, January 18-February 6, 1971

Galerie Rive Gauche, Brussels, May 5-June 4, 1971

Galería Vandrés, Madrid, May 29-June 28, 1973. Catalogue

Galería Ivan Spence, Ibiza, 1973

Galerías Dau al Set, René Métras, Barcelona, *Obras de Porta Zush 1965-71*, November 20-December 21, 1974. Catalogue

Galería Ivan Spence, Ibiza, 1974

Galería Temps, Valencia, April 3-25, 1975. Catalogue

Sala de la Cultura de la Caja de Ahorros de Navarra, Pamplona, October 15-26, 1975. Catalogue

Galería Vandrés, Madrid, *After the Eclipse*, October-November 1976

Marlborough Galeria d'Arte, Rome, *La Morte della mia vita passata*, November-December 1976. Catalogue

Galerie de France, Paris, March 10-April 16, 1977. Catalogue

Galleriet, Lund, Sweden, April 15-May 3, 1978

Galerie Dr. Ursula Schurr, Stuttgart, March 3-April 5, 1979

Galería Vandrés, Madrid, *Yasmu*, January 15-February 16, 1980

Galería Joan Prats, Barcelona, *Tucare*, February 1980

SELECTED BIBLIOGRAPHY

Newspapers and Periodicals

Mireille Aranias, "Zush, le solitaire d'Ibiza," *Spécial* (Brussels), no. 319, May 12, 1971, pp. 59-60

Miguel Fernandez-Braso, "Encuentro con Zush," *ABC* (Madrid), June 2, 1973, pp. 69-70

"Zush," *Pueblo* (Madrid), June 7, 1973

Miguel Veyrat, "Zush: 'ha nacido el hiperrealismo mental,' " *Nuevo Diario* (Madrid), June 7, 1973

Miguel Logroño, "Zush: el individualismo como conducta estética," *Blanco y Negro* (Madrid), June 9, 1973

Elena Florez, "El Misterio y la inteligencia en la obra de Zush"; "Zush: 'Tengo gran esperanza en la renacimiento de la humanidad,' " *El Alcázar* (Madrid), June 23, 1973, p. 29

Javier Rubio, "Una puerta en la Pintura: Zush," *ABC* (Madrid), June 23, 1973

Joaquim Dols Rusiñol, "Porta Zush en Dau al Set," *Destino* (Barcelona), no. 1940, December 7, 1974

María Lluìsa Borràs," Alberto Porta —'Zush,' " *Gazeta del Arte* (Madrid), no. 36, January 30, 1975, pp. 4-5

Luis Figuerola Ferreti, "El Arte en Madrid," *Goya* (Madrid), no. 133, July 1976, pp. 45-46

Santiago Amón, "¿Porta Versus Zush?," *El País* (Madrid), October 1976

Gilles Plazy, "Zush ou l'inattendu," *Le Quotidien de Paris*, March 30, 1977

Bruno Cora, "Zush," *Data* (Milan), no. 26, April-June 1977

Günther Wirth, "Hieroglyphische Felder," *Stuttgarder Zeitung*, March 23, 1979

El País (Madrid), November 9, 1979, p. 5

Books

Zush, *Alberto Porta: La Explosión de la Ments*, Barcelona, 1969

Alexandre Cirici, *L'Art Català Contemporani*, Barcelona, 1970, pp. 255, 297, 321-322, 325, 342

Hans-Jürgen Müller, *Kunst kommt nicht von Können*, Stuttgart, 1976, p. 257

59.
Drobeyena. 1974
Acrylic and pencil on paper, 29 7/8 x
22″ (76 x 56 cm.)
Lent by Galería Vandrés, Madrid

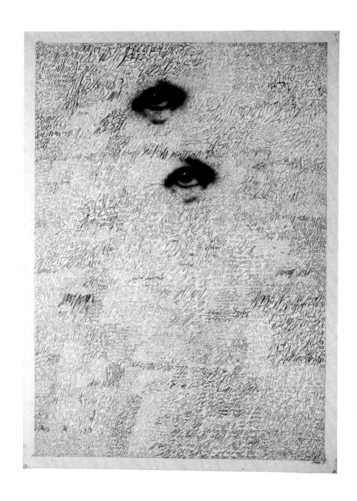

60.
Zizards Nasha. 1975
Pencil, watercolor and collage on
paper, 40⅛ x 28¾″ (102 x 73 cm.)
Collection Lambert, Brussels

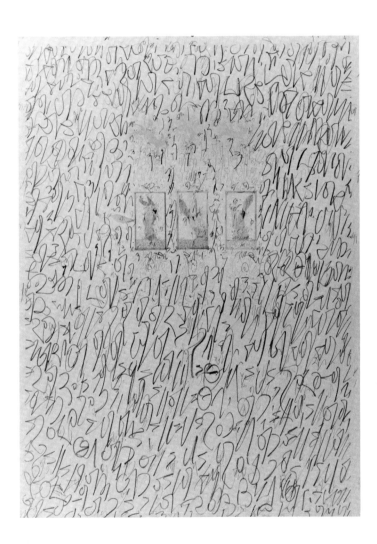

61.

Braeina Heroea. 1975
Pencil, watercolor and collage on
paper, 30¼ x 20⅛" (77 x 51 cm.)
Lent by Galería Vandrés, Madrid

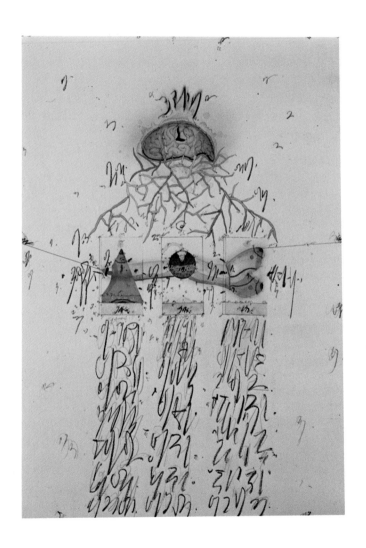

62.
The Death of My Past Life II. 1975
Mixed media on paper, 40⅛ x 28¾″
(102 x 73 cm.)
Collection J. Suñol, Barcelona

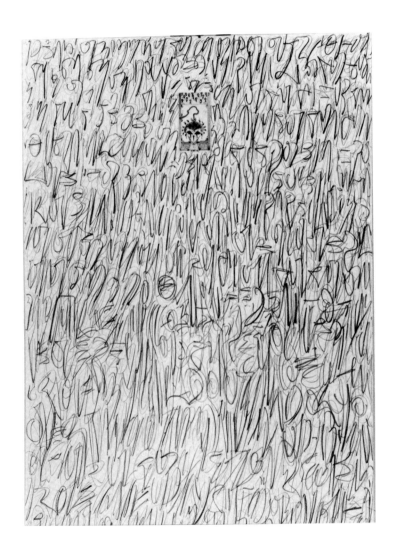

63.
Ego Nara. 1976
Oil, pencil and collage on paper,
22½ x 29⅞″ (57 x 76 cm.)
Lent by Galería Vandrés, Madrid

64.
Africa Verolutzi Euroda Dovest.
1978
Oil, pencil, wax and collage on
paper, 22⅞ x 30⅝″ (58 x 78 cm.)
Lent by Galería Vandrés, Madrid

65.
Time. 1978
Mixed media on paper, 29½ x 41⅜"
(75 x 105 cm.)
Lent by Galería Vandrés, Madrid

66.
Asura-Tucare. 1979
Oil and ink on paper, 41¾ x 27½"
(106 x 70 cm.)
Collection The Solomon R.
Guggenheim Museum, Anonymous
Gift

67.
The Tarot Cards. 1976-79
Mixed media on paper, 7 cards, each
29⅛ x 17⅛" (74 x 43.5 cm.)
Lent by Galería Vandrés, Madrid

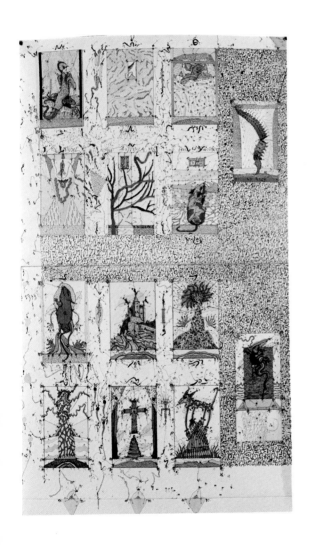

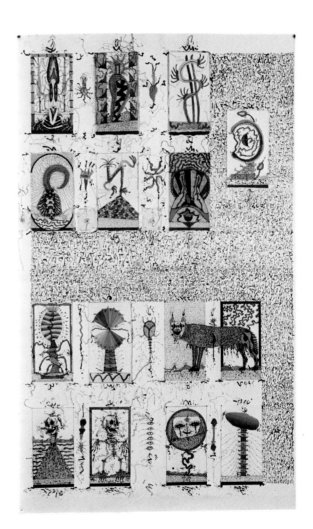

68.
*The World of the Comparative
Baserds.* 1978-79
*(El Mundo de los Baserds
comparables)*
Mixed media on paper, 38 pages,
each 11⅜ x 7⅞" (28.9 x 20 cm.)
Collection J. Suñol, Barcelona

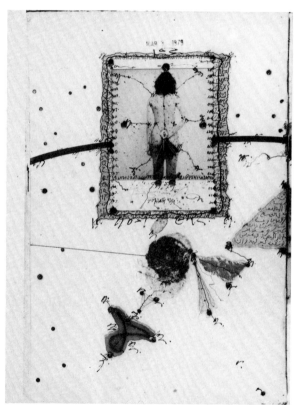

69.
The Book of Feathers. 1978-79
Mixed media on paper, 38 pages,
each 12⅜ x 10¼″ (31.5 x 26 cm.)
Collection the artist

70.
Tucares-Evidas I-IV. 1978-79
Oil, acrylic, pencil and ink on
canvas, 4 panels, each 21 5/8 x 55 7/8"
(55 x 142 cm.)
Lent by Galería Vandrés, Madrid

71.
Vemisiz Evode. 1979
Acrylic on canvas, 76¾ x 113¼″
(195 x 288 cm.)
Lent by Galería Vandrés, Madrid

SELECTED GENERAL BIBLIOGRAPHY

Newspapers and Periodicals

Juan Antonio Aguirre, "New Generation in Spain," *Art and Artists*, no. 12, March 1971, pp. 50-53

María Teresa Blanch, "El Arte Español de 1980: Abstracción y Naturalismo," *Batik* (Barcelona), no. 50, 1979, pp. 5-7

Juan M. Bonet, "Corto viaje a Valencia y a su pintura," *El País* (Madrid), December 23, 1976

Juan M. Bonet, "El arte joven," *La Calle* (Madrid), no. 70, July 24, 1979, pp. 44-45

Valeriano Bozal, "Planteamiento Sociológico de la Nueva Pintura Española," *Cuadernos hispanoamericanos*, no. 235, 1969, pp. 59-60

Victoria Combalia, "Les avantgardes en Espagne," *Art Press* (Paris), no. 22, January-February 1976, pp. 26-27

William Dyckes, "Young Spanish Artists," *Guidepost*, March 10, 1967, p. 25

José-Agusto França, "Espagne 1956-1966," *Aujourd'hui*, no. 52, February 1966, p. 56

Manuel García i García, "Notas sobre la pintura valenciana de los setenta," *Batik* (Barcelona), no. 50, July/August 1979, pp. 43-45

Henri Ghent, "The Second Generation," *Art Gallery*, no. 9, June 1974, pp. 59-65

Henri Ghent, "Spanish Art in Transition," *Art International*, vol. XIX, September 15, 1975, pp. 15-22

Daniel Giralt-Miracle, "Recording Reality," *Art and Artists*, no. 3, June 1977, pp. 30-35

Fernando Huici, "Seis artistas valencianos," *El País* (Madrid), November 3, 1977, p. 26

Jay Jacobs, "Spanish Abstract Art: The First Generation," *Art Gallery*. no. 9, June 1974, pp. 16-22, 68

Hilton Kramer, "Painters and Politics in The New Spain," *The New York Times*, June 3, 1979, pp. D 1, D 27

Gloria Moure, "The Specificity and Dead-end of Spanish Artistic Creation," *Art actuel: Skira annuel*, Geneva, 1979, pp. 142-144

Alvin Smith, "No inspiraciónes Pide el pintor a di'ossino doblones," *Art Gallery*, no. 9, June 1974, pp. 70-73

Exhibition Catalogues

V. Bozal and T. Llorens, "Spagna: Vanguarda Artistica, Realità Sociale," *Biennale Internazionale d'Arte*, Venice, June-October 1976, pp. 176-185

Francisco Calvo and Angel González García, *Crónica de la Pintura de postguerra: 1940-1960*, Madrid, Galería Multitud, October-November 1976

Juan Eduardo Cirlot, *Millares Canogar Rivera Saura*, New York, Pierre Matisse Gallery, March 15-April 9, 1960

Victoria Combalia, "España: el medio artístico en un momento de transición," *10e Biennale de Paris*, 1977, pp. 36-38

Frank O'Hara, *New Spanish Painting and Sculpture*, New York, The Museum of Modern Art, July 20-September 25, 1960

Books

Juan Antonio Aguirre, *Arte Ultimo*, Madrid, 1969

V. Bozal and T. Llorens, eds., *España. Vanguardia artística y realidad social: 1936-1976*, Barcelona, 1976

Vicente Aguilera Cerni, *Iniciación al arte español de la postguerra*, Barcelona, 1970

Alexandre Cirici, *L'Art catalá contemporani*, Barcelona, 1969

William Dyckes, ed., *Contemporary Spanish Art*, New York, 1975

J. Marín-Medina, J. Molas and A. Puig, *Dau al Set; 30 años después*, Barcelona, n.d.

PHOTOGRAPHIC CREDITS

WORKS IN THE EXHIBITION

Color

Manuel Bragado, Richard Conahay, Elias Dolcet and Juan Dolcet: cat. nos. 13, 17, 41, 45, 47, 50, 51, 54, 61, 67

Ramón Calvet: cat. nos. 2, 5

Courtesy Teresa Gancedo: cat. nos. 22, 27

Muntadas: cat. no. 28, pp. 78, 79

Courtesy Miquel Navarro: cat. nos. 30, 33

Black and White

Manuel Bragado, Richard Conahay, Elias Dolcet and Juan Dolcet: cat. nos. 14-16, 18, 19, 31, 32, 34-36, 38, 40, 42-44, 46, 48, 49, 52, 53, 55-59, 60, 62-66, 68-71

Ramón Calvet: cat. nos. 1, 3, 4, 6-11

Courtesy Carmen Calvo: cat. no. 12

Courtesy Teresa Gancedo: cat. nos. 20, 21, 23, 24a, 24b, 25, 26

Muntadas: cat. no. 28, pp. 77-80

Courtesy Miquel Navarro: cat. nos. 29, 37

FIGURES IN THE TEXT

Courtesy William Dyckes: p. 27

Courtesy Galerie Karl Flinker, Paris: p. 16 bottom

Courtesy *Guadalimar*, Madrid: p. 30

Courtesy Antonio López-García: p. 21

Courtesy Marlborough Gallery Inc., New York: pp. 13 bottom left, 23

Robert E. Mates and Mary Donlon: pp. 11, 12

Courtesy Pierre Matisse Gallery, New York: p. 13, top, bottom right

Courtesy Galería René Métras, Barcelona: p. 16 top left

Courtesy Juana Mordo: p. 18

Muntadas: p. 25

Courtesy Galería Vandrés, Madrid: p. 16 top right

PHOTOGRAPHS OF THE ARTISTS

Francisco José Alberola, Valencia: pp. 48, 82

Joan Borràs: p. 38

Richard Conahay: pp. 96, 106

Courtesy Teresa Gancedo: p. 58

G. Mezza: p. 68 left

Domingo Sarrey: p. 116

Tamiranda: p. 68 right

Courtesy Zush: p. 126

EXHIBITION 80/3

4,500 copies of this catalogue, designed by Malcolm Grear Designers, typeset by Dumar Typesetting, Inc., have been printed by Eastern Press in March 1980 for the Trustees of The Solomon R. Guggenheim Foundation on the occasion of the exhibition *New Images from Spain.*

SERGI AGUILAR

CARMEN CALVO

TERESA GANCEDO

THE SOLOMON R. GUGGENHEIM MUSEUM, NEW YORK

MUNTADAS/SERRÁN PAGÁN

MIQUEL NAVARRO

GUILLERMO PÉREZ VILLALTA

JORGE TEIXIDOR

DARÍO VILLALBA

ZUSH